D0186971

SAN FRANCISCO
GIANTS

FRONT COVER: Here is a never-before-published photograph of pitcher Juan Marichal. See page 37. (Courtesy of Doug McWilliams, photographer.)

COVER BACKGROUND: The scoreboard at Candlestick Park is pictured in 1992. See page 95. (Courtesy of Bob Lurie.)

BACK COVER: Pictured are Willie McCovey, Charles "Pete" Stoneham, and Willie Mays. See page 23. (Courtesy of Pete Stoneham.)

SAN FRANCISCO
GIANTS

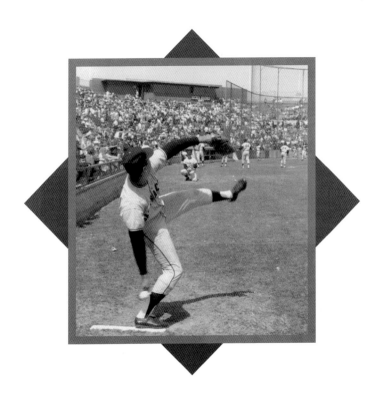

Tricia O' Brien
Foreword by Will Clark

ARCADIA
PUBLISHING

Copyright © 2011 by Tricia O' Brien
ISBN: 978-0-7385-7612-1

Published by Arcadia Publishing
Charleston, South Carolina

Printed in the United States of America

Library of Congress Control Number: 2011929293

For all general information, please contact Arcadia Publishing:
Telephone 843-853-2070
Fax 843-853-0044
E-mail sales@arcadiapublishing.com
For customer service and orders:
Toll-Free 1-888-313-2665

Visit us on the Internet at www.arcadiapublishing.com

CONTENTS

FOREWORD

Excited doesn't come close to describing the feeling when in 1986 general manager Al Rosen gave some kids a chance and let us play ball.

On April 8, 1986, I faced Nolan Ryan in the Houston Astrodome for my first major league at-bat, and when that fastball came on the third pitch, "Pow!" I hit a home run to center field! After the hit, I pointed and acknowledged my family and friends—about 40 of them—in the stands. What a dream come true!

From 1988 on, I was third in the lineup. Bob Brenly and Mike Krukow concocted my nickname, "Will the Thrill," because one day I said I was thrilled to be here, and they gave me grief. But I truly was thrilled and wasn't afraid to show it. Roger Craig instilled the home field advantage at Candlestick in us, but I wanted to win every game. I took the field wanting to win, wanting to beat my opponent. Other teams knew this, it was no secret, and I believe there was mutual respect.

My other fairytale moment was during Game 5 of the National League Championship Series, getting the pennant-clinching hit off Mitch Williams with the bases loaded in the eighth inning—sending us to the World Series. Winning MVP was icing on the cake. I really thought we were going to be champions in 1989, but Mother Nature and the Oakland A's had different plans. After the earthquake and dealing with the tragedy, the emotions, and the time-off, it just wasn't meant to be.

When I played, the team had chemistry. We fed off each other, motivated each other, and did our best to win. I remember taking 500 swings a day, hitting every combination imaginable to prepare. It meant a lot to me, and we had a job to do because it meant a lot to the fans.

It has been fun to watch this current group of guys rally together, support each other, and bring home a World Series championship.

The Giants have had star rosters for decades. Some of the greatest players ever to play baseball have worn the orange and black. It's nice to see that some of that history is being preserved and shared in this book for future generations. Thank you to the fans for electing me to go to the All-Star Game six times. I'm honored to be back working with the Giants as a special assistant and team ambassador, offering what I can to help the team.

Hope you enjoy reading this history. Sit back and enjoy.

—Will Clark, No. 22
Giants Infielder, 1986–1993

ACKNOWLEDGEMENTS

This book would not have been possible without the help of my personal Hall of Fame.

John Poultney, my editor who went to bat for me and made this book possible. Bill Laskey, the owner/CEO of Celebrity Connection, my friend, and all-time favorite Giant. Doug Johnson, who puts up with me on a daily basis, thank you for your love and support. Michael McGauley, copy editor and proofreader, historical contributor, cheerleader, and voice of reason. Will Clark, thank you so much for all of your help and providing the foreword. Doug McWilliams, photographer, I can't thank you enough for lending me your personal photographs. Barry Colla, photographer/CEO of Barry Colla Photography & Design, thank you for your amazing photographs. Pete Stoneham, thank you for lending me your family photographs and stories. Bob Lurie, thank you for your time and for letting me invade your office and personal albums.

I would also like to thank Dusty Baker, Nick Belloni, Ron Blatman, Vida Blue, Rob Butcher, Carol Camacho, Orlando Cepeda, Matt Chisolm, Jim Davenport, Cee Jay Dawes, Marco Di Gino, Hank Greenwald, Martin Jacobs, Mikell Kelly, Don Kynaston, Tim Little, Richard Macaluso, Morton Mah, Steve Mavromihalis, Mike McCormick, John Moist, Ed Montague, Mike Murphy, Stephen Nichols, Sara and John Palladino, Gaylord Perry, Bob Quinn, Troy Russell, Eanna and Mercedes Sarah, Staci Slaughter, Danny Smith, Doug Smith, Matt Soderstrom, Harlon "Bud" Stafford, Denise and Pete Stoneham, Kim, Marc and Edward Tuite, Wes, Casie, Shannon and Kaylee Woodland, Kate Zawistowski, Kim Zimmerman, and my colleagues at Pacific Union International for your support. And, a special thank-you to my Simon, Sebastian, and Bailey for putting a smile on my face every single day.

INTRODUCTION

The Giants organization has been home to some of the greatest players to ever play baseball. Each fan has their favorite player or players, typically based upon the decade in which they were a child. The players who are familiar to fans and the players who don't always get as much attention can be found on these pages. This book offers a broad cross section and only touches the surface of the team's history. Although it does not cover every single player ever to wear the orange and black, the book will definitely bring back some memories. As the decades fade away, so do the memories, unless history is preserved and passed along to future generations.

In the 1950s through the 1960s, the Giants' rosters included some of the finest players in baseball. In fact, the organization developed five hall of famers at the same time; no other team has done this. Most of the players simply felt blessed that they had been given a talent and an opportunity to play ball. It was an era of baseball when players grew up in an organization and where relationships with teammates were essential. The role they played together—both on and off the field—helped to create a unified team. In the offseason, the guys had second jobs to pay the bills and support their families. But the locker room was a secure place where teammates supported each other during the season. Players felt that part of the fun was finding a roommate they clicked with and could hang out with off the field and on road trips. In 1962, the team lost the World Series to the New York Yankees. Despite having some of its greatest teams, the Giants didn't make it make back to the fall classic the rest of the decade.

In the 1970s, the team had its ups and downs, and while there was camaraderie, there never seemed to be a one-through-nine balanced roster. The early 1980s ushered in a new era, and eventually they were back in contention, reaching the World Series against the Oakland Athletics in 1989. They appeared in the World Series again in 2002 but fell short to the Anaheim Angels. The team almost left San Francisco a couple of times, but it was saved thanks to the efforts of Bob Lurie and Peter McGowan. After several failed attempts to seek public funding, a new privately financed ballpark was finally erected and opened in 2000.

In the post–Barry Bonds era, pitching became a focus through the draft. The Giants' young starting pitchers helped anchor the team's historic playoff run in 2010. While not considered a favorite to win it all, the team delivered a long-awaited World Series championship. They showed that they were a true team who supported each other and wanted to win. The victory parade and celebration was one of the biggest, most joyous, and peaceful events ever seen in the Bay Area. Anyone who has ever been associated with the Giants was part of the party. The team truly recognized the win was not just for them; it was for everyone who ever played for the Giants.

NEW YORK GIANTS

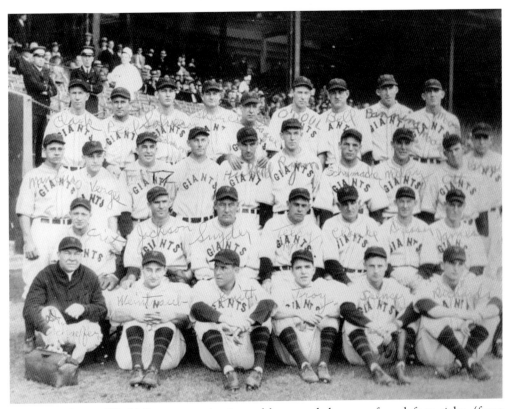

The 1933 Giants World Series team is pictured here, and they are, from left to right, (front row) Doctor Schaeffer, Phil Weintraub, coach Al Smith, mascot Sam Troy, Glenn Spencer, and Paul Richards; (second row) Hughie Critz, Travis Jackson, coach Frank Snyder, Bill Terry, coach Tommy Clarke, Chuck Dressen, and Bernie James; (third row) Gus Mancuso, Johnny Vergez, Freddie Fitzsimmons, Kiddo Davis, Carl Hubbell, Blondy Ryan, Hal Schumacher, Joe Malay, Mel Ott, and Roy Parmalee; (fourth row) Watty Clark, Homer Peal, Jack Salveson, Bill Shores, Dolf Luque, Lefty O'Doul, Hi Bell, Harry Danning, and Jo-Jo Moore. The Giants beat the Washington Senators in four out of five games. Carl Hubbell, Mel Ott, Bill Terry, and Travis Jackson are all in the Hall of Fame. (Courtesy of Pete Stoneham.)

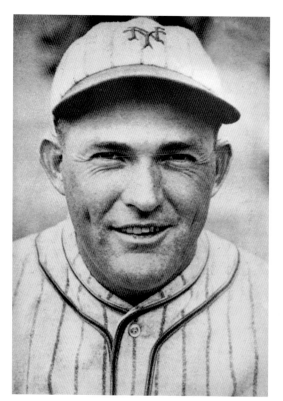

Rogers Hornsby played and helped manage the New York Giants in 1927. He had 205 hits and batted .361, with 125 runs batted in; however, his gambling habits irritated owner Charles Stoneham enough to trade him after just one year. He is known as one of the greatest hitters of all time and is in the Hall of Fame. (Courtesy of Pete Stoneham.)

Pitcher Christy Mathewson is still considered one of the greatest players in Giants franchise history. He started with the team in 1900. He has 373 career wins, 80 shutouts, and 2,500 franchise strikeouts. Mathewson won two Triple Crowns for pitching and has two career no-hitters. He was the first Giant to be inducted into the Hall of Fame. (Courtesy of Hank Greenwald.)

WORLD CHAMPIONS

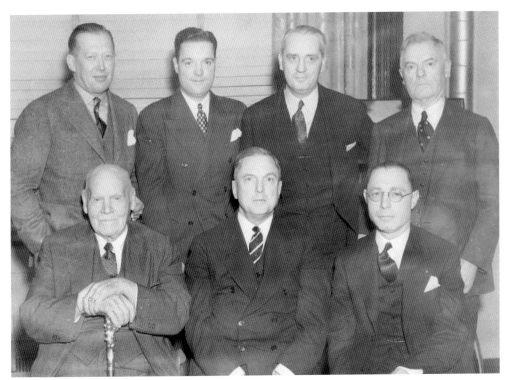

In the winter, the men in charge of the National League met to discuss the upcoming 1936 schedule and other business matters. In this photograph, pictured from left to right are (first row) Judge Stephen W. McKeever, president of the Brooklyn Dodgers; Sam Breadon, president of the St. Louis Cardinals; and William E. Benswanger, president of the Pittsburgh Pirates; (second row) Larry MacPhail, general manager of the Cincinnati Reds; Horace C. Stoneham, president of the New York Giants; Gerald P. Nugent, president of the Philadelphia Phillies; and J.A. Robert Quinn, president of the Boston Bees. (Courtesy of Pete Stoneham.)

Pictured here are Horace Stoneham, Del Webb, and Leo "The Lip" Durocher. Horace Stoneham, president of the New York Giants, liked the fiery Durocher and approached Dodgers general manager Branch Rickey to see if a swap could be reached. On July 16, 1948, Durocher shocked the baseball world when he announced he would be moving to the rival Giants. While he was with the Giants, they beat the Dodgers in a one-game tiebreaker for the 1951 National League pennant. Then in 1954, the Giants swept the Indians in the World Series. (Courtesy of Pete Stoneham.)

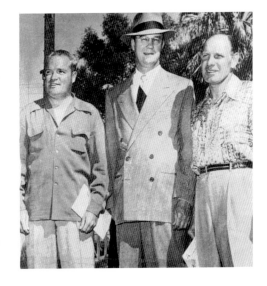

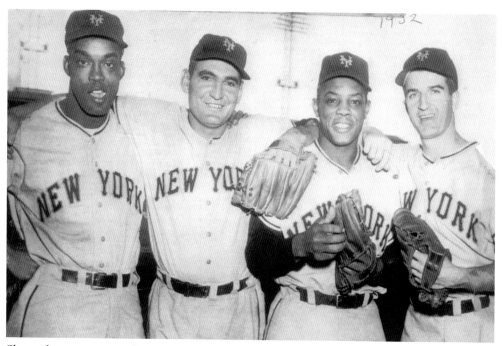

Shown here are power players Monte Irwin, Dusty Rhodes, Willie Mays, and Don Mueller. In 1951, Irwin, Mays, and Hank Thompson were the first all-black outfield in the major leagues. Mueller broke his ankle in a 1951 playoff game. His hit advanced Alvin Dark, but Mueller missed Robert "Bobby" Thomson's famous home run, known as the "Shot Heard 'Round the World" or "Miracle of Coogan's Bluff." Mueller also missed the World Series. (Courtesy of Pete Stoneham.)

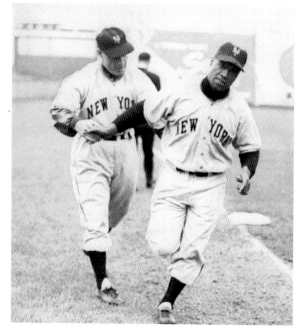

Shown here are coach Leo Durocher and third baseman Hank Thompson. Thompson fought in the Battle of the Bulge before becoming a baseball star. He played for the Giants from 1949 to 1956, becoming the first black player to have played in both the National League and American League. He was an amazing hitter who hit two inside-the-park home runs in a single game in 1950. (Courtesy of Pete Stoneham.)

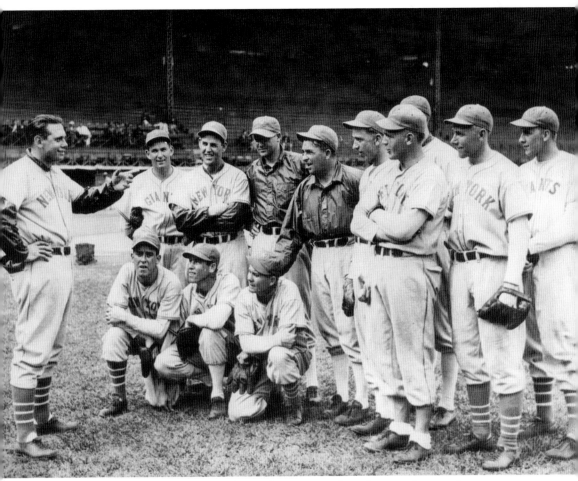

Manager Bill Terry lets the players know that Horace Stoneham is the team's new owner. Horace's children inherited the team from his father, Charles, in 1937. Since the children were very young at the time, Horace took over the daily ownership responsibilities. Bill Terry played first base for the team and later took over the managerial duties from John McGraw, leading the team to the 1933 World Series title over the Washington Senators. (Courtesy of Pete Stoneham.)

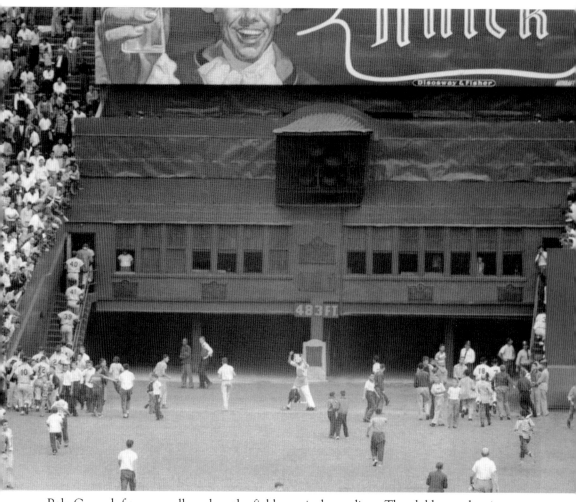

Polo Grounds fans were allowed on the field to exit the stadium. The clubhouse dressing rooms were located above the exit, with visitors on the left side and the home team on the right side. Mays's famous World Series catch known as "The Catch" in 1954 took place just to the right of this exit. (Courtesy of Hank Greenwald.)

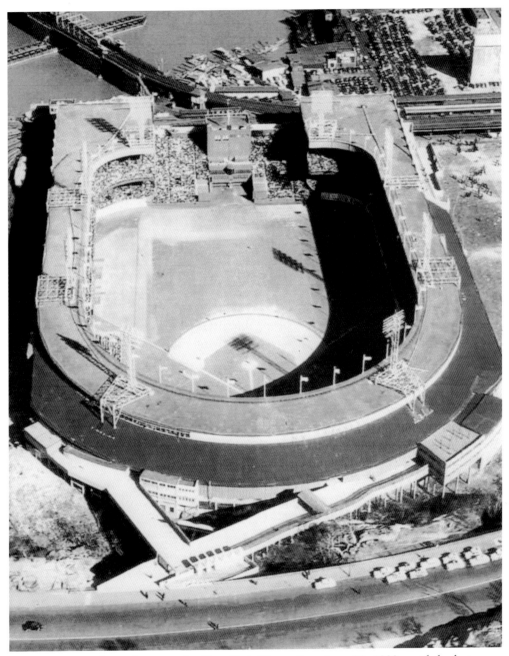

The Polo Grounds was home to the New York Giants from June 28, 1922, until the last game on September 29, 1957. Located at West 155th Street in Harlem, the stadium had a distinctive horseshoe shape with a short right and left field but an extra-long center field. It was the fourth location to carry the Polo Grounds name. From 1913 to 1922, the Yankees also called this stadium home, as did the Mets from 1962 to 1963. The structure was demolished in 1964. Stoneham had tried for years to get a new home for the Giants, and after several unsuccessful attempts he started making arrangements to move the team. (Courtesy of Pete Stoneham.)

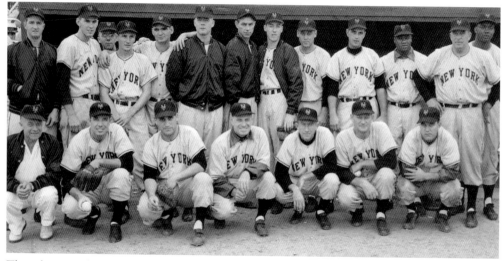

This photograph was taken in 1953 in Okinawa at a stop off during the 1953 Japanese Good Will Tour. Pictured from left to right are (first row) trainer Jim Hearn, Sam Calderone, Leo Durocher, Bill Rigney, Marv Grisson, and Bob Hofman; (second row) Ron Samford, Daryl Spenser, trainer Dave Williams, Jim Rhodes, Al Worthington, Montia Kennedy, Al Corwin, Don Mueller, Hoyt Wilhelm, Hank Thompson, Fred Fitzsimmons, and Monty Irvin. (Courtesy of Pete Stoneham.)

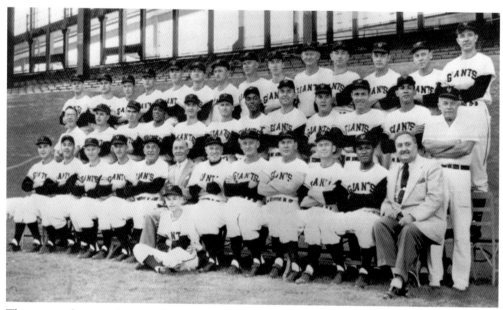

This team photograph was taken in 1954, which was the year they swept the World Series against the heavily favored Cleveland Indians. (Courtesy of Pete Stoneham.)

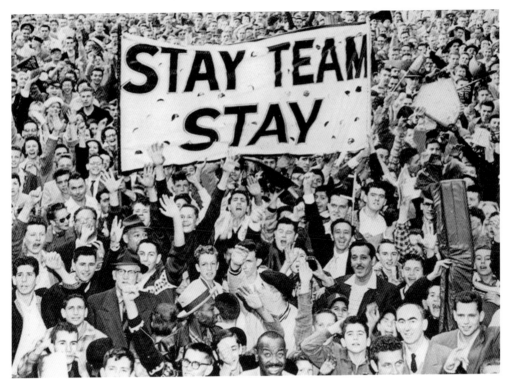

New York fans shared their thoughts with a "Stay Team Stay" banner. In New York, people were passionate about their teams. They were either National League or American League fans. The only thing the Giants and Dodger fans had in common was their common enemy—the Yankees. Every day of every year, people talked about who was going to get the best of the other team, because they were usually competing for the top spot. The move of two extremely successful franchises, the Giants and Dodgers, happened quickly and was shocking. (Courtesy of Richard Macaluso.)

Sal Maglie was the last pitcher to pitch for all three of the New York baseball teams. He was a fierce and feared competitor, and he earned his nickname "The Barber" because he was not afraid to throw inside and "buzz" the batter. As a Giant, he won 11 consecutive games in 1951 and led the team to their last New York pennant in 1954. He pitched in memorable games, such as the Bobby Thomson "Shot Heard 'Round the World," and the famous Willie Mays World Series catch. When the Giants moved to the West, Maglie remained in New York and joined the Yankees. (Courtesy of Pete Stoneham.)

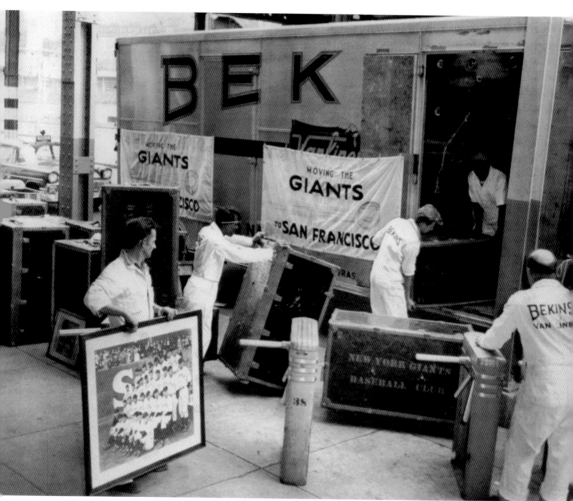

Moving day arrived, and everything had to go West. Horace Stoneham was first going to sell the team and move them to Minneapolis. However, when Brooklyn Dodgers owner Walter O'Malley heard of the move, he convinced Stoneham to move the team westward to keep the rivalry intact in California. (Courtesy of Hank Greenwald.)

WELCOME TO
SAN FRANCISCO

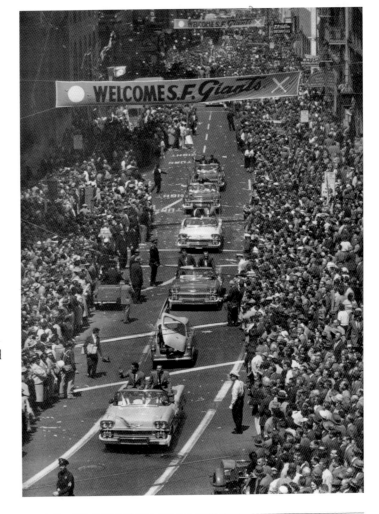

San Francisco threw a huge ticker-tape parade to welcome the Giants after they moved to the West Coast. Jim King and Bob Speak are in the first car. Willie Mays and Daryl Spencer are in the second car. The third car holds pitcher Curt Barclay and catcher Bob Schmidt. In the last car is Ramon Monzant, and it is believed that Willie Kirkland is the other occupant. (Courtesy of Pete Stoneham.)

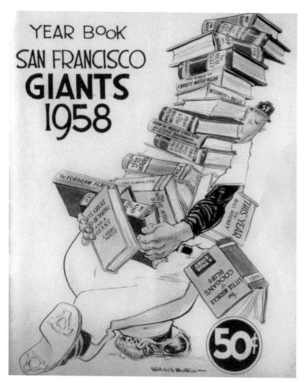

This is the first yearbook for the San Francisco Giants. The artist had some fun with the past history of the team, highlighting various themes and stars in the volumes of history books carried by the cartoon ballplayer. (Courtesy of Richard Macaluso.)

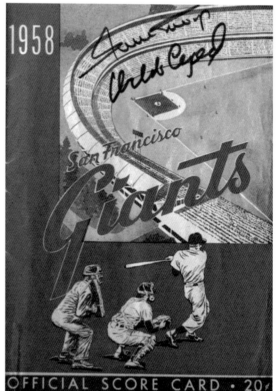

Shown here is the first official scorecard of the San Francisco Giants. The owner of this particular scorecard got an extra score—note the signatures of Willie Mays and Orlando Cepeda. (Courtesy of Richard Macaluso.)

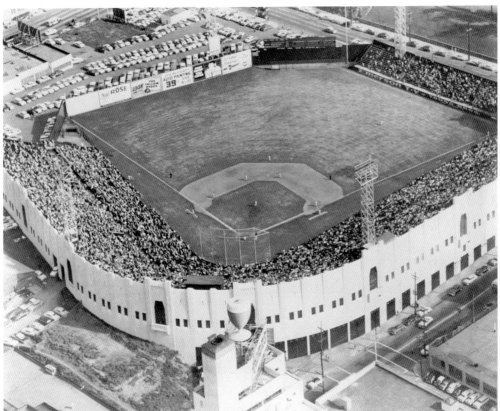

Seal Stadium, home to the San Francisco Seals, was a small stadium with an intimate feel. It was located in Potrero Hill on Sixteenth Street between Bryant Street and Potrero Avenue. You can also see part of Hamm's Brewery across the street. The Giants played their first two seasons in San Francisco at Seal Stadium before moving to Candlestick Park in 1960. The first game was an 8-0 victory over the Dodgers. Nearly every game the Giants played here was a sellout. (Courtesy of Pete Stoneham.)

This promotional flyer let fans know they could purchase tickets to see the Giants play at Seal Stadium for either $3.50 for box seats or $2.50 for reserved seats. Or they could listen to Russ Hodges and Lon Simmons on KSFO. (Courtesy of Bob Lurie.)

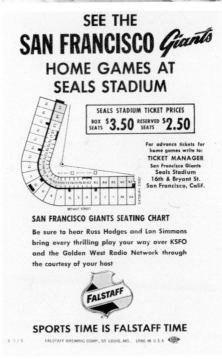

SEE THE

SAN FRANCISCO *Giants*

HOME GAMES AT SEALS STADIUM

SEALS STADIUM TICKET PRICES

BOX SEATS $3.50 RESERVED SEATS $2.50

For advance tickets for home games write to:
TICKET MANAGER
San Francisco Giants
Seals Stadium
16th & Bryant St.
San Francisco, Calif.

SAN FRANCISCO GIANTS SEATING CHART

Be sure to hear Russ Hodges and Lon Simmons bring every thrilling play your way over KSFO and the Golden West Radio Network through the courtesy of your host

FALSTAFF

SPORTS TIME IS FALSTAFF TIME

FALSTAFF BREWING CORP., ST. LOUIS, MO. LITHO. IN U.S.A.

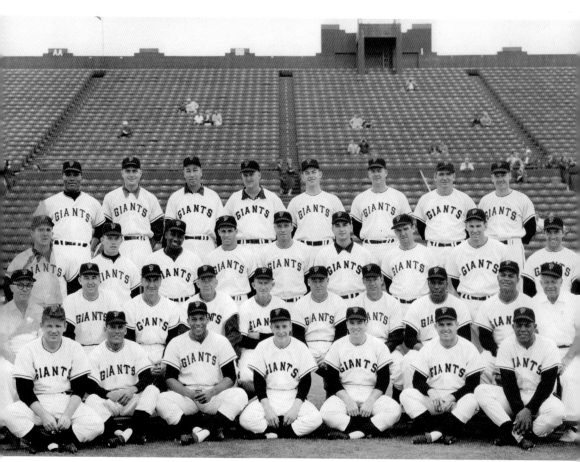

This 1959 team photograph was taken at Seal Stadium. What a lineup, with the likes of Willie Mays, Willie McCovey (Rookie of the Year), Orlando Cepeda, Dusty Rhodes, Hobie Landrith, Mike McCormick, Stu Miller, and Jim Davenport. (Courtesy of Pete Stoneham.)

WELCOME TO SAN FRANCISCO

WILLIE MAYS AND WILLIE MCCOVEY

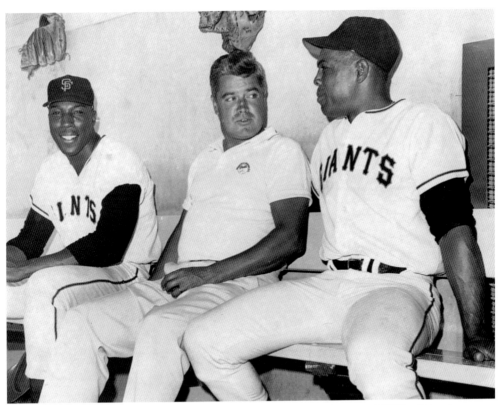

In this photograph, Willie McCovey, Charles H. "Pete" Stoneham, and Willie Mays hang out in the dugout during spring training in Arizona. Stoneham felt that he had two of the best players in baseball on his team. Horace liked the family feel of his organization, and his son Pete eventually served as team president. (Courtesy of Pete Stoneham)

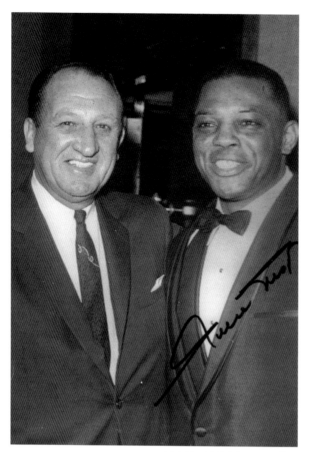

Ed Montague signed Willie Mays to the Giants in 1950. In the 1930s, Montague was a shortstop for the Cleveland Indians. At the time they met, Mays was playing for the Birmingham Black Barons in the Negro leagues, and Montague was on a scouting mission tasked with watching Alonzo Perry. Once Montague saw Mays, he forgot about Perry and concentrated on Mays. Montague was a scout for the Giants for over 45 years. He also ran the Giants rookie team in South San Francisco. Ed's son Eddie Jr. became a "rock star" among umpires in Major League Baseball, working six World Series—four of them as crew chief. Montague was the second-base umpire on May 28, 2006, when Barry Bonds hit his 715th home run to pass Babe Ruth for second place all-time. (Courtesy of Ed Montague.)

This photograph shows manager Leo Durocher and Willie Mays in the dugout in 1951. While Mays had talent from the start and came from Minneapolis with an amazing batting average, he was a little sluggish in the beginning. With Durocher's firm guidance, he quickly settled in. After he hit a gigantic home run, he found his comfort zone and never looked back. (Courtesy of Pete Stoneham.)

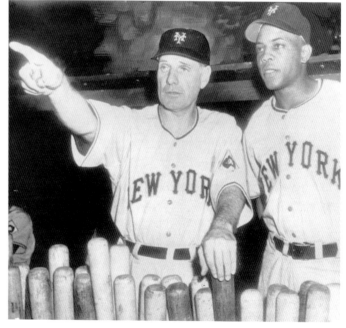

William Howard Mays Jr., more commonly known as Willie Mays or the "Say Hey Kid," is the greatest Giant ever and one of the greatest players in the history of the game. He learned baseball from his father, who played in the Negro leagues. Willie would also play in the Negro leagues in the late 1940s. (Courtesy of Pete Stoneham.)

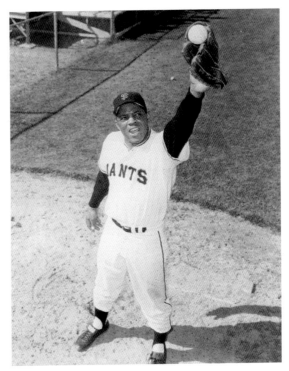

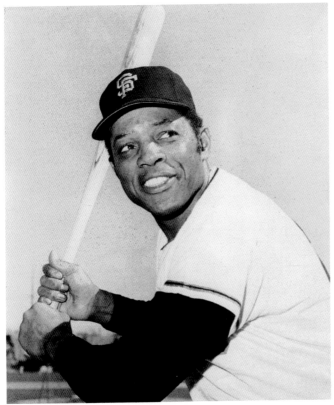

Born in Westfield, Alabama, Willie Mays was special from the start. In 1951, he was the first Giant to win Rookie of the Year. He won the National League batting title in 1954. He was the first National League player to hit 30 home runs and steal 30 bases in a single season. In 1965, he hit 51 home runs and was the National League Most Valuable Player. In total, he hit 660 career home runs, 646 of those as a Giant. He could hit, catch, and run. (Courtesy of Pete Stoneham.)

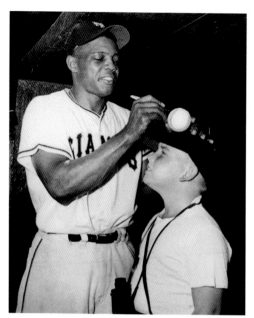

On April 30, 1961, Willie Mays became the first and remains the only Giant to hit four home runs in a single game. Fans everywhere worshipped him and sought his autograph, and he was happy to oblige. (Courtesy of Richard Macaluso.)

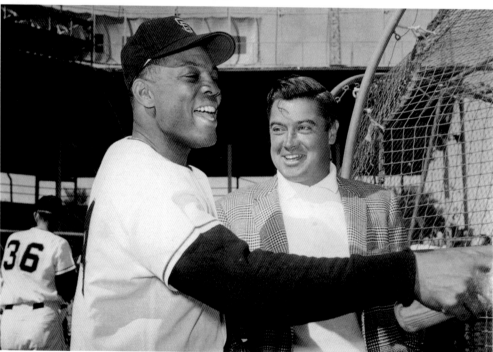

In this image, Willie Mays and Charles "Pete" Stoneham share a moment during training. Stoneham thought that Willie Mays was one of the best all-around players ever. Mays won many awards, including 12 Gold Gloves, two National League MVP awards, the 1951 Rookie of the Year, the 1971 Roberto Clemente Award, and had 24 All-Star appearances. He had 660 home runs in his career and won a World Series championship in New York. (Courtesy of Pete Stoneham.)

WILLIE MAYS AND WILLIE MCCOVEY

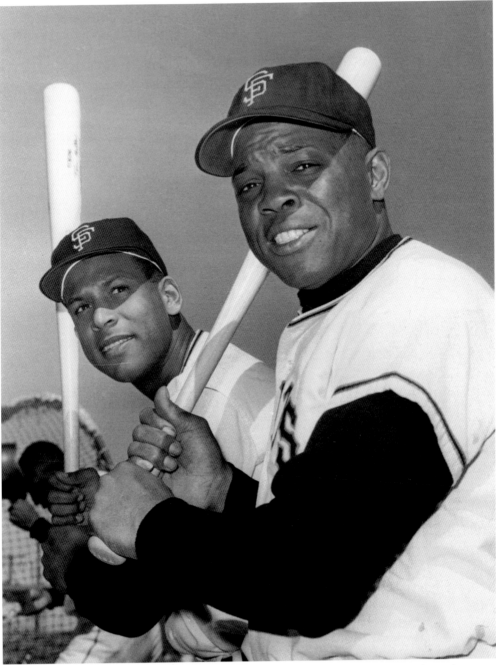

Willie Mays and Orlando Cepeda were two of the finest players in baseball. Watching them was a treat; they made it all look so easy. (Courtesy of Pete Stoneham.)

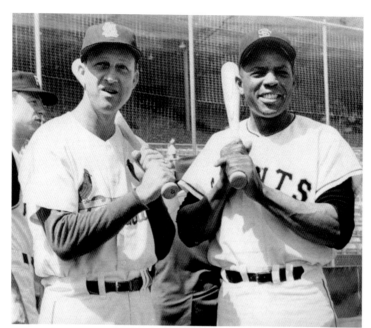

Pictured here are two greats, Stan "The Man" Musial of the St. Louis Cardinals and Willie Mays, before the 1961 All-Star Game at Candlestick Park. Musial won three National League MVP awards, and Mays won two MVP awards. But both had 24 All-Star appearances. (Courtesy of Pete Stoneham.)

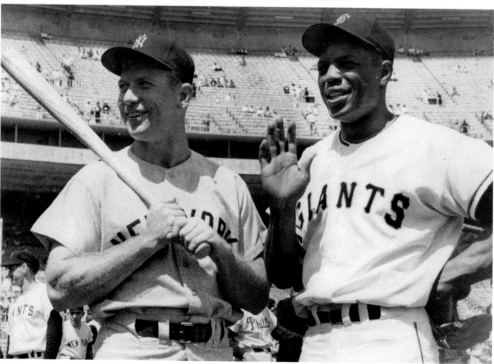

Hanging out before the first All-Star Game ever played at Candlestick Park are Mickey Mantle and Willie Mays. Mantle was one of six Yankee All-Stars that year. Three other Giants joined Mays to represent the home team: Orlando Cepeda, Mike McCormick, and Stu Miller. The following year, the Giants and Yankees would face each other in the 1962 World Series. (Courtesy of Pete Stoneham.)

WILLIE MAYS AND WILLIE MCCOVEY

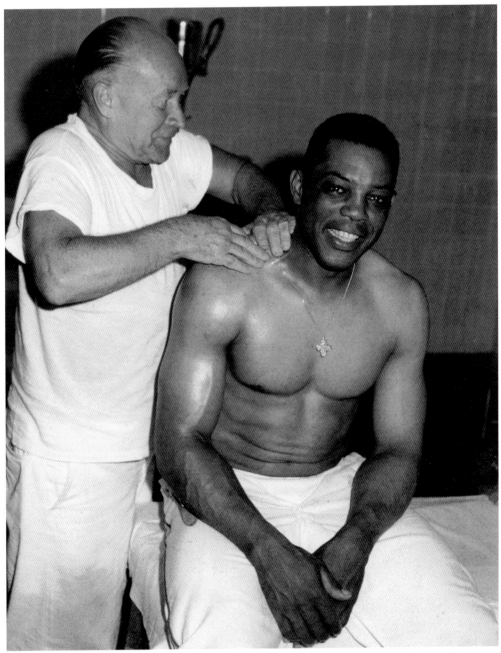

This photograph shows Willie Mays getting a rubdown from trainer Frank Bowman a few hours before Game 1 of the 1962 World Series. Mays started off the season with a home run against Warren Spahn of the Milwaukee Braves. A few years later, Spahn finished his career with the Giants at the age of 44. (Courtesy of Martin Jacobs.)

Willie Mays is at bat, with José Azcue of the Cleveland Indians catching during an exhibition game at Edmonds Field in Sacramento on April 12, 1964. This field was used by the Sacramento Solons of the Pacific Coast League. (Courtesy of Doug McWilliams, photographer.)

This flyer was created for Willie McCovey's first game in the major leagues. When he arrived in San Francisco, he must have been wondering how he was going to fit in with Orlando Cepeda already at first base. The only glove McCovey owned was a first-baseman's glove. He went four-for-four at the plate in his first game against the Philadelphia Phillies, and may have put his mind at ease. McCovey went on to win Rookie of the Year, even though he only played half of the year. He also had a 22-game hitting streak that year. (Courtesy of Hobie Landrith.)

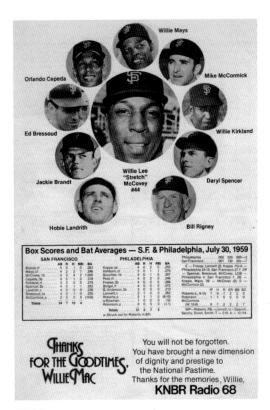

Box Scores and Bat Averages — S.F. & Philadelphia, July 30, 1959

You will not be forgotten.
You have brought a new dimension of dignity and prestige to the National Pastime.
Thanks for the memories, Willie.
KNBR Radio 68

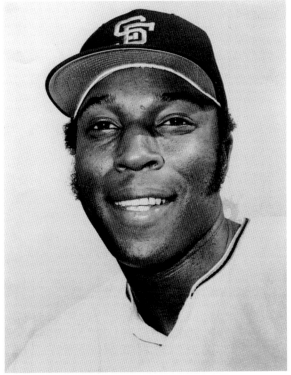

Willie McCovey was born in Mobile, Alabama, and spent 19 of 22 seasons with the Giants wearing No. 44, which was the same as Hank Aaron and Reggie Jackson. He was called up in July 1959 and proceeded to produce from the very start. Orlando Cepeda, the existing first baseman, was not being quiet about his dislike of third base, and McCovey was placed in the outfield and even sent back to the minors for a brief period. By 1963, he had a regular spot in the lineup playing first base. His was nicknamed "Big Mac" and "Stretch," the latter because of his ability to literally stretch great lengths to make plays. (Courtesy of Pete Stoneham.)

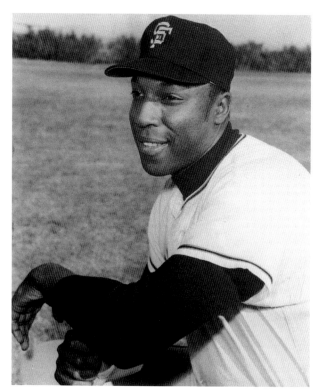

Willie McCovey had a powerful swing, and even his teammates said they had never seen such a feared hitter. He had 521 career home runs as a left-hander, which was the highest in the National League until 2001 when Barry Bonds passed him. McCovey finished with 18 career grand slams, making him second at the time to Lou Gehrig. He is now fifth on the all-time list. He was the very first player to hit two home runs in a single inning twice in his career, and one of them was a grand slam to boot. (Courtesy of Pete Stoneham.)

McCovey led the National League with 44 home runs in 1963, 36 home runs in 1968, and 44 home runs again in 1969. For four consecutive seasons, from 1967 to 1970, he led the National League in home-run percentage. In 1969, he hit 45 home runs, drove in 126 runs, and won the National League MVP Award. He ended his career with 521 home runs, tying Ted Williams on the all-time home run record list.

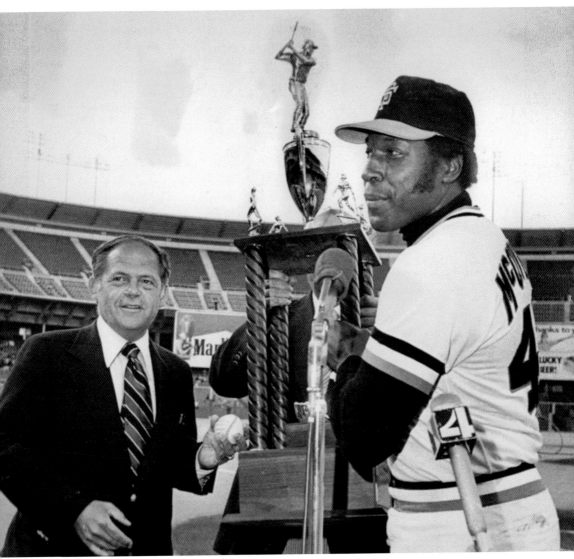

In 1974, McCovey was traded away to the San Diego Padres and also played a part of a season with the Oakland A's in 1976. When Bob Lurie took over the team in 1977, he brought Big Mac back to the Orange and Black. McCovey did not disappoint, blasting 28 home runs and driving 86 runs, capturing the Comeback Player of the Year Award. (Courtesy of Bob Lurie.)

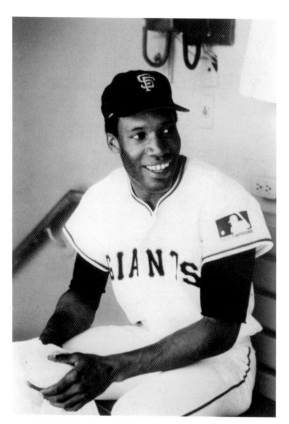

In 1968, Bobby Bonds christened his major-league debut against the Los Angeles Dodgers with a grand slam. He possessed a combination of speed and hard hitting. He was the first player to have multiple seasons with over 30 home runs and 30 stolen bases, and he did this in both leagues. Bonds also had quick feet in the outfield. He was the type of player who would be looking for a fly ball and might have made two steps to the left, but then he would realize he had misjudged the ball. He would still be able to adjust and make the play. He was hyped as the next Mays. (Courtesy of Pete Stoneham.)

Bobby Bonds went on to become an amazing hitting coach for the team in 1993, when his son Barry signed with the Giants as a free agent. Bobby Bonds was with the Giants for a total of 23 seasons. He died in 2003 at the age of 57. (Courtesy of Pete Stoneham.)

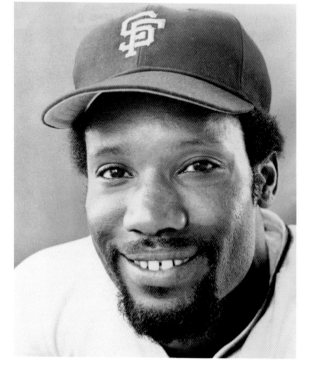

WILLIE MAYS AND WILLIE MCCOVEY

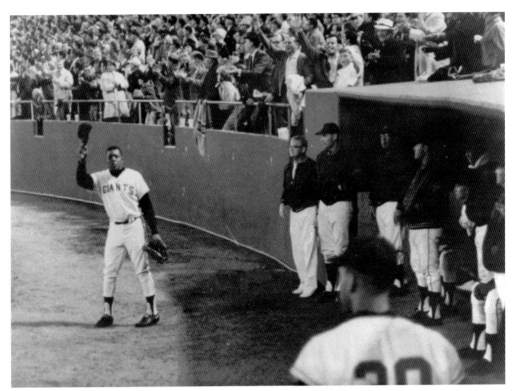

Willie Mays acknowledges the cheers of the crowd after hitting his record 600th home run in September 1969. The Giants were facing San Diego rookie pitcher Mike Corkins, and the home run won the game. Mays was named Player of the Decade in the 1960s by the *Sporting News*. (Courtesy of Pete Stoneham.)

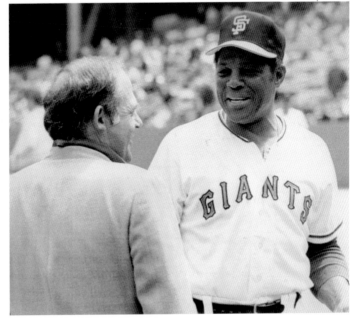

In 1972, Mays was traded to the New York Mets and played the final two years of his career hitting just 14 home runs. (Courtesy of Bob Lurie.)

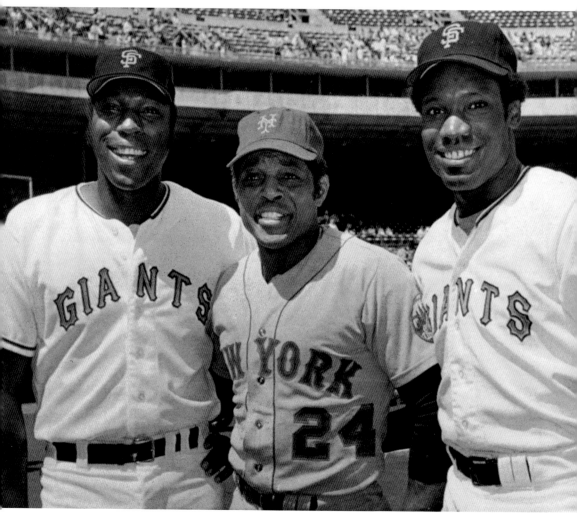

Stoneham claimed that he hated to see players go, and he often brought them back. But he still managed to trade away a number of his star players over the years. Three in particular include Willie Mays, traded to the New York Mets in 1972; Willie McCovey, traded to the San Diego Padres in 1974; and Bobby Bonds, traded to the New York Yankees in 1975. (Courtesy of Pete Stoneham.)

THE EARLY YEARS

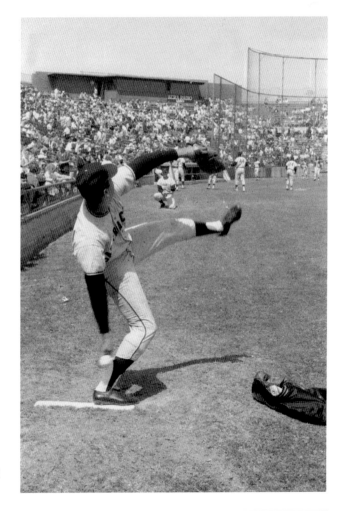

In this photograph, Juan Marichal warms up before an exhibition game in 1964 at Edmonds Field in Sacramento. One of the greatest Giants pitchers, he immediately stood out with his signature high leg-kick wind up and superb control of his power pitches. In 1963, Marichal threw the first San Francisco no-hitter for the team, shutting down Houston in a 1-0 win. (Courtesy of Doug McWilliams, photographer.)

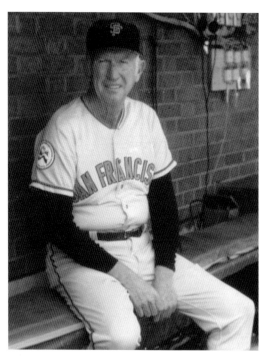

Former outfielder Bill Rigney was the first manager of the San Francisco Giants. They were a half game out of first place when George Shinn replaced him, and then later Alvin Dark replaced Shinn. Rigney played outfield for the New York Giants from 1946 to 1953. (Courtesy of Richard Macaluso.)

1960 SAN FRANCISCO GIANTS

This 1960 scorecard shows a picture of Candlestick Park with one section still open. Hoping that a ballpark would be named after him, contractor Charles Harvey donated the land at Candlestick Point to the city. Fans were given the opportunity to choose a name, which prompted Harvey to walk away without finishing some of the features of the park. Things like steam-heat seats had problems from the beginning. The location and windy weather were not properly described to the Stonehams prior to ground-breaking.

THE EARLY YEARS

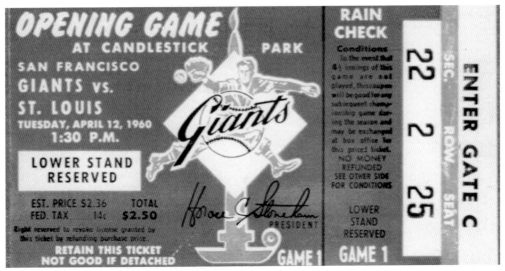

On April 12, 1960, it was opening day for the Giants in their new stadium named Candlestick Park. While everyone was excited to have a larger, newer stadium with parking, Candlestick quickly gained a reputation as one of the worst parks in the country for both players and fans. (Courtesy of Richard Macaluso.)

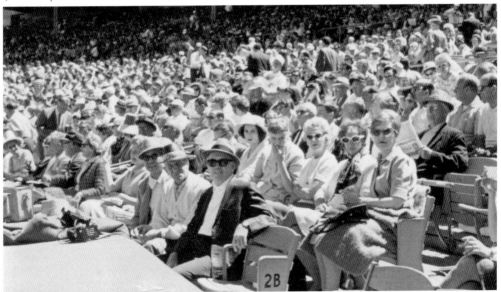

In the early days of Candlestick Park, fans dressed up when they attended a ball game. The Stonehams used to rent an apartment at 1730 Kearny Street in San Francisco from Dr. and Mrs. Collin Dong. Doctor Dong was also Willie McCovey's doctor. The families became friends, and the Dongs often sat in the Stonehams' seats to watch the Giants at Candlestick Park. The three gentlemen in row 2B, from left to right, are golfing buddies Dr. Collin H. Dong, Ray Burns, and Charlie Lazzari. In the next row up on the aisle is Mildred Valpey Dong, and next to her are believed to be Angie Svenson, Daisy Lazzari, and Dorothy Burns. (Courtesy of Galen Dong and Melissa Dong Mountain.)

Hobie Landrith had been with the St. Louis Cardinals when he came to the Giants with Sam Jones in 1959, claiming it was the best thing that ever happened to him. He was a fearless catcher. He broke his wrist prior to opening day at Candlestick Park. Vice Pres. Richard Nixon, who was due to throw out the first pitch, had asked to meet the team. Hobie was quite relieved when Nixon didn't extend his hand for a firm handshake and instead asked how Hobie's wrist was healing. Hobie responded that he was progressing. (Courtesy of Hobie Landrith.)

In 1949, way before he joined the Giants, a young Hobie Landrith and Johnny Vander Meer of the Cincinnati Reds discussed their plan. Vander Meer pitched two consecutive no-hitters in 1938. Landrith was only 15 years old when a Detroit Tigers scout asked him if he wanted to catch batting practice with Hank Greenberg. The managers were impressed, and he went on to play for the Esquire All-American Boys team and the Hearst All-American Team. There was no draft at that time, but when Landrith was ready, his father got all of the scouts together in the house on the same day. Being a die-hard American League fan growing up, Landrith wanted to be a Detroit Tiger, but his father picked Cincinnati. By the age of 20, Landrith started in the major leagues. (Courtesy of Hobie Landrith.)

THE EARLY YEARS

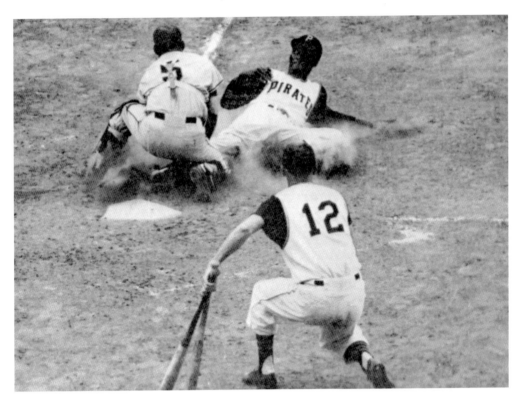

In this photograph taken in May 1960, Hobie Landrith blocks home plate and tags Roberto Clemente of the Pittsburgh Pirates while Pirates shortstop Dick Schofield looks on. (Courtesy of Hobie Landrith.)

Hobie Landrith caught Juan Marichal's first game. (Courtesy of Hobie Landrith.)

Joe Amalfitano was signed as a "bonus baby" and only played nine games for the team from 1954 to 1955. From 1960 to 1961, the infielder played full-time before Houston took him as part of the expansion draft. He went back to the Giants in 1963 for only 54 games, and then he went on to the Chicago Cubs. He coached for the Giants from 1972 to 1975 and spent 16 years as the Dodgers' third-base coach under Tommy Lasorda from 1983 to 1998. Amalfitano currently works in the front office as a roving instructor and the Giants' special-assignment scout. (Courtesy of Pete Stoneham.)

Jim Davenport was born in Siluria, Alabama. He was offered a football scholarship in the Southeastern Conference. Alabama was his choice, but they did not take married people so he switched to baseball. In 1955, he signed with the Giants and played third base in the minors with Orlando Cepeda. Once in the majors, he typically hit first or second in the lineup. After Jim Ray Hart came up, Davenport moved from third base to second base and shortstop. He won the Gold Glove as third baseman in 1962. Hobie Landrith was his roommate in 1961. Back then everyone had a roommate on the road. He was also a close friend of Bobby Bonds. During the offseason, Jim Davenport, Mike McCormick, and Tom Haller all lived locally. They helped out in the public relations department and took season ticketholders out to lunch. (Courtesy of Jim Davenport.)

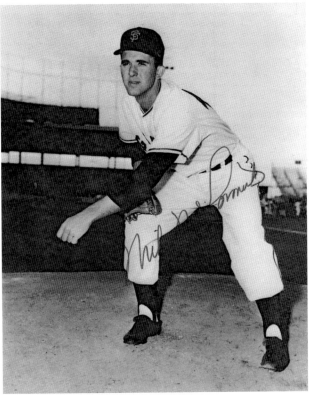

Mike McCormick was just a kid when, at 17 years old, he found himself in the major leagues. He pitched for the New York Giants from 1956 to 1958 and for the San Francisco Giants from 1958 to 1970. In 1967, he won the National League Cy Young Award and was named Pitcher of the Year by the *Sporting News*. It was the first time the award was split between the National League and the American League. Red Sox pitcher Jim Lonborg won for the American League. McCormick has personalized license plates that say "500," in honor of the 500th home run. He was the pitcher who gave up Hank Aaron's 500th home run in 1968. (Courtesy of Russell Moshier.)

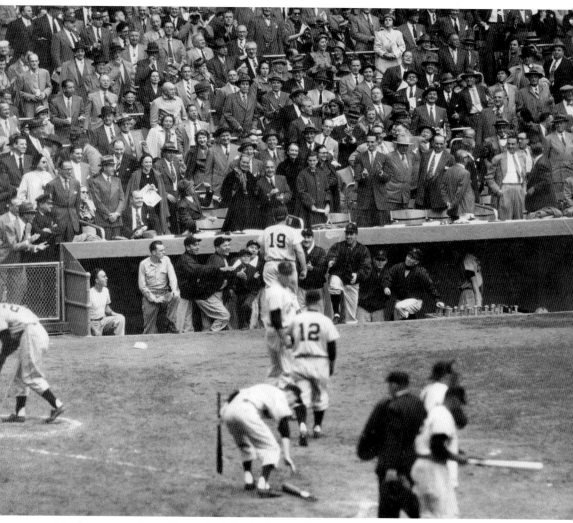

This photograph shows Game 1 of the 1951 World Series. Shortstop Alvin Dark, No. 19, had just hit a three-run home run against the Yankees. He went on to play in the 1954 World Series and had a hit in every game. Dark was a star football and baseball player in college. (Courtesy of Pete Stoneham.)

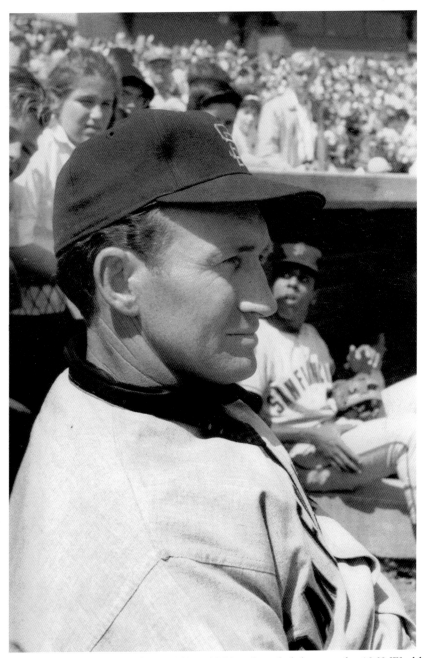

Alvin Dark managed the Giants from 1961 to 1964 and guided them to the 1962 World Series. He was a technically sound manager who knew exactly what moves he was going to make innings in advance. Back then, managers had a one-year contract. It was "win or be fired," so the team had to be productive right away. If players had any infractions, he would charge them boxes of golf balls and give the boxes to other players as a reward. The players would make a point of thanking the player who made the payment. Stoneham fired Dark at the end of the 1964 season. (Courtesy of Doug McWilliams, photographer.)

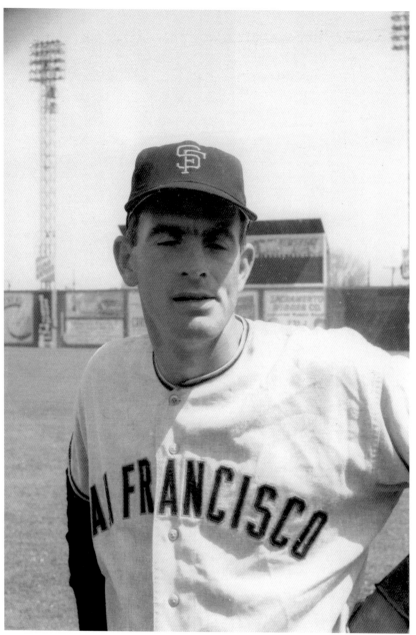

Hall of Fame pitcher Gaylord Perry was born in Williamston, North Carolina, and signed with the Giants right out of high school. Perry's agent told him that he would be playing with the greatest ball players ever, and his agent was right. In 1964, a reporter for the *San Francisco Examiner* joked with manager Alvin Dark about the new kid, Perry, and asked if he was going to hit any home runs. Dark joked back that a man would land on the moon before Perry hits a home run. On July 20, 1969, during a game against the Dodgers, the news was announced over the loudspeaker that *Apollo 11* had just landed on the moon. About 30 minutes later, Perry hit his first home run. He hit five more after that. (Courtesy of Doug McWilliams, photographer.)

THE EARLY YEARS

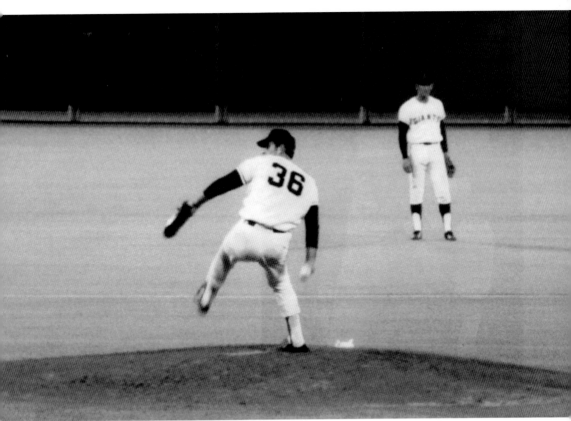

Gaylord Perry had incredible control of the ball and often finished what he started, throwing 300 complete games. On September 17, 1968, he threw a no-hitter against the St. Louis Cardinals. The next day, Ray Washburn of the Cardinals threw a no-hitter against the Giants. During that game, Perry went around to his teammates offering $100 if they got a hit. Two weeks prior, Perry threw a one-hitter and at the time thought it would be the closest he would ever come to a no-hitter. He was the first player to win the Cy Young Award in both the American League and National League. He played in six All-Star Games for both leagues and was one of 11 pitchers to reach 200 strikeouts in both leagues. Randy Johnson, who briefly played for the Giants in 2009, is also on this list. (Courtesy of John Moist, photographer.)

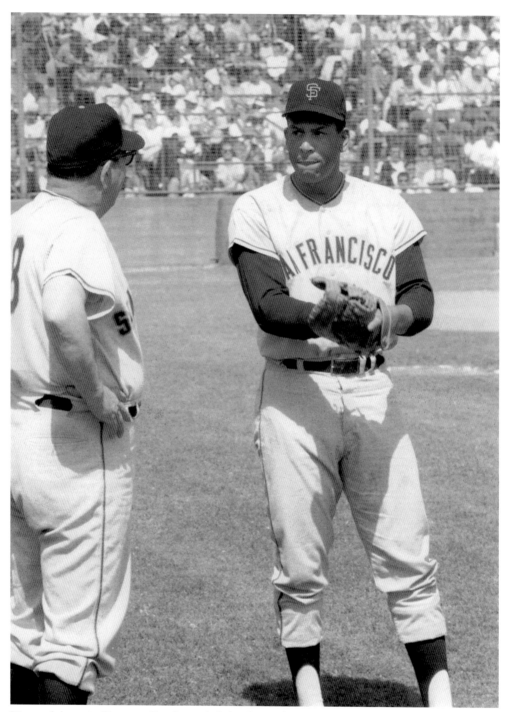

Pictured here is Herman Franks and Orlando "Baby Bull" Cepeda at an exhibition game in Sacramento, California. Cepeda was a great hitter and was the 1958 Rookie of the Year. In 1966, Cepeda was traded to the St. Louis Cardinals for Ray Sadecki. (Courtesy of Doug McWilliams, photographer.)

THE EARLY YEARS

Orlando Cepeda, Bob Shaw, and Chuck Hiller are pictured in the dugout at Edmonds Field in Sacramento. Pitcher Bob Shaw was traded by the Milwaukee Braves for Felipe Alou, Ed Bailey, Billy Hoeft, and Ernie Bowman. In 1962, Hiller was the first National League player to hit a grand slam in the World Series during Game 4 against the New York Yankees. (Courtesy of Doug McWilliams, photographer.)

SAN FRANCISCO GIANTS

Tom Haller was born in Lockport, Illinois. Prior to signing with the Giants, he was a quarterback for the University of Illinois. He was the starting catcher for the Giants from 1962 to 1967 and was pitcher Gaylord Perry's very first catcher. Haller was traded to the Dodgers in 1968 for Ron Hunt and Nate Oliver. It was the first trade between the rival teams since 1956. (Courtesy of Doug McWilliams, photographer.)

Harvey Kuenn born in West Allis, Wisconsin. He was an infielder and outfielder for the Giants from 1961 to 1965. Kuenn made the last out in two of Dodger Sandy Kofax's no-hitters in 1963 and 1965, and he later managed the Milwaukee Brewers. (Courtesy of Doug McWilliams, photographer.)

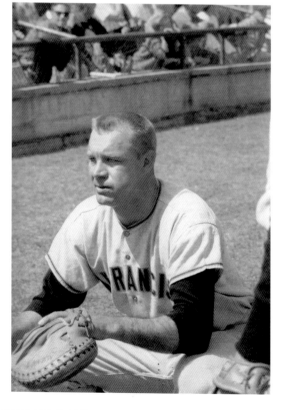

THE EARLY YEARS

Ron Herbel was called up in 1963 after spending five years in the minor leagues. As a pitcher, he won only 42 games during his career but had his best season in 1965, winning 12 games and helping the team get within two games of the first-place Dodgers. (Courtesy of Doug McWilliams, photographer.)

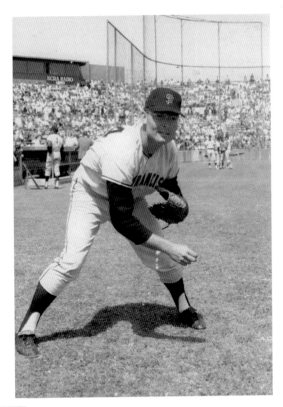

Catcher Bob Barton signed with the Giants as an amateur free agent in 1959 and then started with the Giants on September 17, 1965. He was a star basketball player in high school, but he chose baseball while at the University of Kentucky. (Courtesy of Doug McWilliams, photographer.)

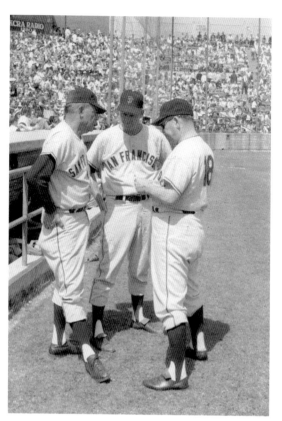

Shown here in 1964 are coaches Cookie Lavagetto, Whitey Lockmann, and Herman Franks. Lavagetto was primarily a third baseman playing in the major leagues for the Pittsburgh Pirates, the Brooklyn Dodgers, and the Oakland Oaks of the Pacific Coast League. Lockmann played for the New York Giants, scoring the tying run before Bobby Thomson's famous "Shot Heard 'Round the World." He is the third-base coach in this photograph. Franks is a former player and coach from the team's New York days and took the team to four consecutive second-place finishes in the 1960s, making them the best second-place team around. (Courtesy of Doug McWilliams, photographer.)

Jack Sanford won Rookie of the Year as a pitcher with the Philadelphia Phillies in 1957, but he was traded to the Giants after the 1958 season for Valmy Thomas and Ruben Gomez. In 1962, he led the team with 24 wins, including 16 in a row. He came in second place to Don Drysdale in the National League Cy Young Award voting. (Courtesy of Doug McWilliams, photographer.)

THE EARLY YEARS

For most of his career, Billy Pierce had been with the Chicago White Sox. He joined the Giants on November 30, 1962, when Alvin Dark traded three pitchers for Pierce and Don Larsen. Pierce helped the Giants win the pennant in 1962. It was in a three-game tiebreaker against the Dodgers, and Pierce pitched a three-hit shutout to send the team to the World Series. (Courtesy of Doug McWilliams, photographer.)

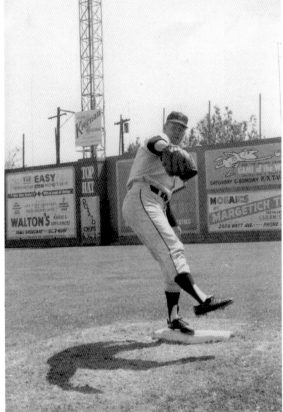

Billy O'Dell was born in Whitmore, South Carolina, and had his best season as a pitcher in 1962. He pitched in the World Series, including the ninth inning of Game 7. In 1962, O'Dell and Pierce, two former American League left-handers, combined for 35 wins, 19 and 16 respectively. (Courtesy of Doug McWilliams, photographer.)

Mateo "Matty" Alou was born in Haina, Dominican Republic. Matty and his brothers Felipe and Jesús were the only all-brother outfield in all of Major League Baseball. Matty was especially known for his speed and was on third base when Millie McCovey made the last out of the 1962 World Series. McCovey crushed a line drive that was caught by Yankees second baseman Bobby Richardson. (Courtesy of Doug McWilliams, photographer.)

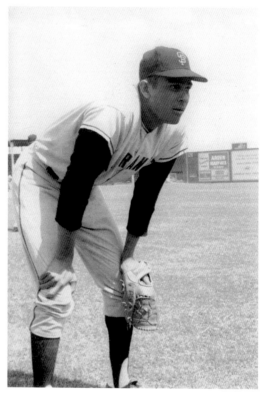

Jesús Alou was born in Haina, Dominican Republic. He was an outfielder for the Giants from 1963 to 1968. In 1964, when his brother Felipe left the team, Jesús moved to right field. He was often the victim of Mike McCormick and Ray Sadecki's magic tricks. (Courtesy of Doug McWilliams, photographer.)

Bob Bolin grew up a Brooklyn Dodgers fan, but in 1956, he made the choice to sign with the New York Giants as an amateur free agent. He started in the minors then moved up to the major leagues in 1961. He pitched two games in the 1962 World Series. In 1970, he was traded to the Milwaukee Brewers. (Courtesy of Doug McWilliams, photographer.)

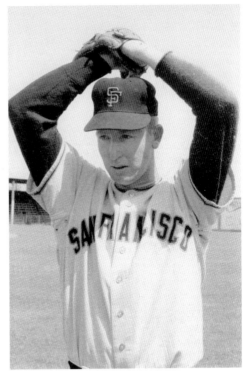

Larry Jansen was a star pitcher for the Giants in the 1940s and 1950s. During the 1951 playoff game against the Brooklyn Dodgers, he was struggling when Bobby Thomson hit his famous home run, giving Jansen, the Giants, and their fans a win for the ages. In 1954, he became a pitching coach for the Giants. (Courtesy of Doug McWilliams, photographer.)

Jim Duffalo was a right-handed relief pitcher who played the majority of his career with the Giants, starting in 1961. In 1962, he played in the playoff series but did not play in the World Series. (Courtesy of Doug McWilliams, photographer.)

Originally from Puerto Rico, José Pagán was a shortstop for the Giants. His best year was 1962, when he played in every game and led the National League in fielding. Pagán also had career highs with 150 hits, 25 doubles, and13 stolen bases to help the team win the pennant. In 1965, he was traded to the Pittsburgh Pirates in exchange for shortstop Dick Schofield. (Courtesy of Doug McWilliams, photographer.)

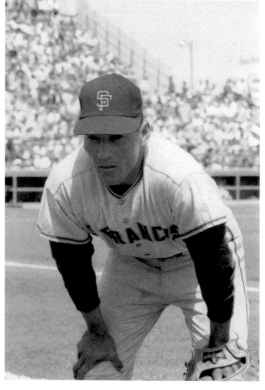

Juan Marichal was born in Laguna Verde, Dominican Republic. He had incredible control of the ball, sporting a career ERA of 2.89. In 1960, he pitched a one-hit shutout in his first game against Philadelphia. In total, he pitched 52 shutouts as a Giant, earning the nickname "The Dominican Dandy." He won 25 games in a season twice and, in 1968, he was 26 and 9 with 30 complete games and 218 strikeouts. He retired as a Dodger in 1975, but he didn't get a win in either of his two starts with this team. (Courtesy of Pete Stoneham.)

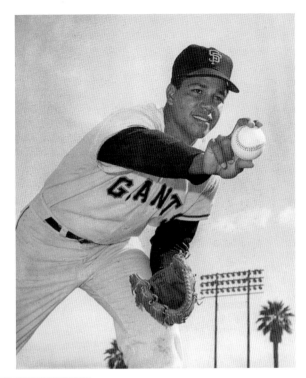

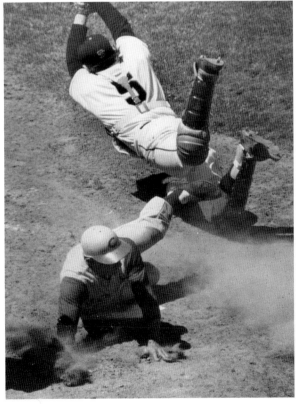

Hobie Landrith dives for the ball as Billy Martin slides into home plate. Martin went on to have a very successful managerial career with the New York Yankees and the Oakland Athletics. (Courtesy of Hobie Landrith.)

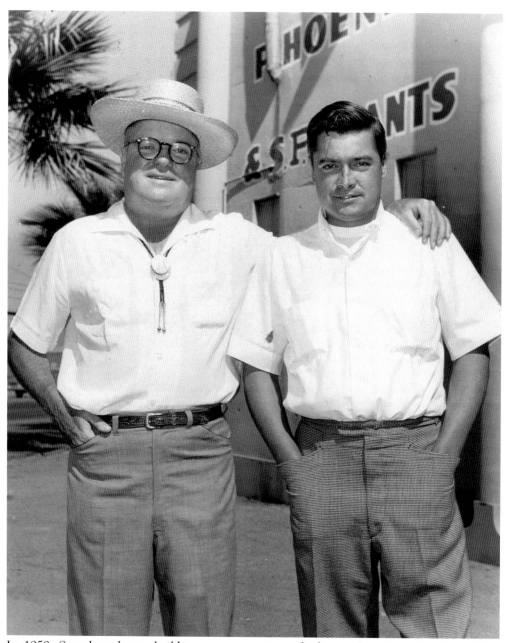

In 1959, Stoneham began building a spring-training facility at Francisco Grande in Casa Grande, Arizona. The Giants played their first exhibition game there in 1961. Horace and his son Pete are shown here in front of the stadium. More recently, the team has trained at the new Scottsdale Stadium since 1992, but their history in Scottsdale goes back to the 1950s. (Courtesy of Pete Stoneham.)

In 1949, the Pink Pony Restaurant, Scottsdale's oldest, opened its doors. Charlie Brinley started as the bartender and became the restaurant's owner in 1950. Brinley and some investors decided to build a stadium where ballplayers could train. They are credited with bringing spring training to Scottsdale, Arizona. Many baseball deals were done in the right corner booth and in the backroom of the Pink Pony during the 1960s and 1970s. The umpires sat in the opposite corner, and players had their favorite tables from which they threw various items at the umpires. Disney animator Don Barkley drew caricatures of the regulars, and Charlie decided who would be drawn and hung on the walls. (Courtesy of The Pink Pony.)

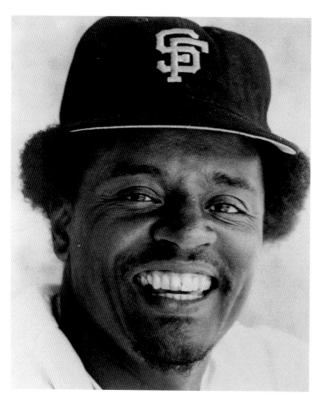

Rigoberto "Tito" Fuentes was born in Havana, Cuba. In 1962, he was one of the last players signed out of Cuba before the US embargo. Late in the 1965 season, he debuted in the majors, playing second base and shortstop. He spent 1968 in the minor leagues, and by 1971, he was back in San Francisco at second base. In 1971, the team made the National League Championship Series, and Fuentes hit a two-run homer that helped the Giants win their only game of the series, falling to the Pittsburgh Pirates in four games. After the 1974 season, he was traded to the San Diego Padres for Derrel Thomas. (Courtesy of Pete Stoneham.)

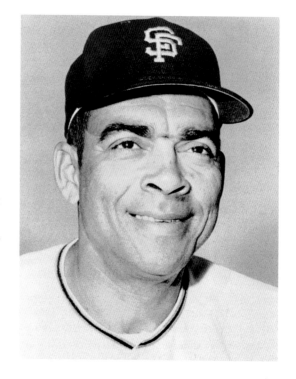

Ozzie Virgil was the first player from Dominican Republic to play Major League Baseball. Primarily a third baseman, he played every position except pitcher and center field. From 1956 to 1957, he played for the New York Giants, and in 1966 and again in 1969 he played for the San Francisco Giants. He was with the Giants' AAA team in Phoenix in 1967 and 1968. He coached for the Giants in 1969 to 1972 and 1974 to 1975. His son Ozzie Jr. also played in the majors. (Courtesy of Pete Stoneham.)

THE EARLY YEARS

From the Tough Years
to Triumph

In 1976, Horace Stoneham had made arrangements to move the team. Bob Lurie, who was on Stoneham's board, wanted to find a way to prevent the move. Lurie arranged a noon conference call with all of the National League owners. They didn't like Candlestick Park and liked the idea of the team moving to Toronto. Lurie asked for 48 hours to make a decision, but they gave him five hours (until 5:00 p.m.). Walter O'Malley, who was instrumental in getting Stoneham to move from New York to San Francisco, did not want the rivalry between the Giants and Dodgers to leave the state. Bud Herseth in Phoenix, the biggest independent meatpacker, talked to Cory Bush in the San Francisco Mayor's Office and told Bush he wanted to get involved. Then, within an hour, Bush and Lurie verified that Herseth had the required $4 million in the bank. Buzzie Bavasi vouched for Herseth at 5:00 p.m. Lurie called the owners back and made a 50-50 deal, with Lurie as the decision maker. Herseth's wife read about the deal in the newspaper. One year later, Lurie bought out Herseth and took full control of the team. (Courtesy of Bob Lurie.)

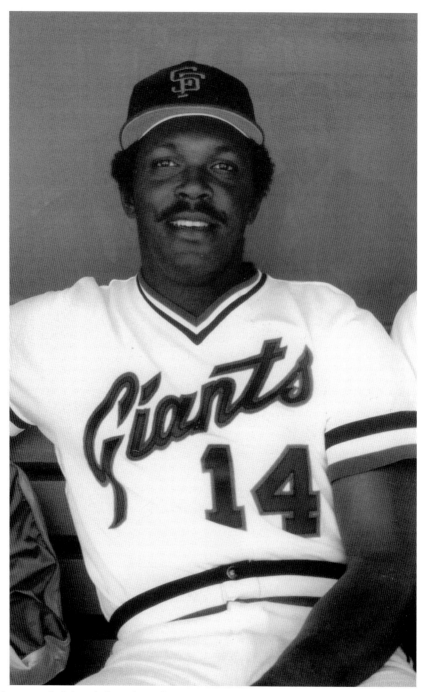

Vida Blue was a left-handed pitcher who was famous for his fastball, but he also had a curveball and change-up that kept batters on their toes. Born in Mansfield, Louisiana, he never dreamed that he would play in the major leagues, let alone have a successful 17-year career, or win the American League Cy Young Award in 1971 as an Oakland Athletic. (Courtesy of Richard Macaluso.)

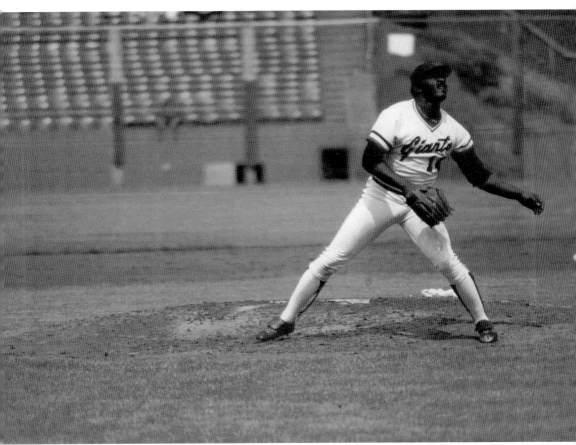

Vida Blue played for the Giants from 1978 to 1981, and again from 1985 to 1986. In this photograph, he is on the mound at Candlestick Park watching a fly ball. He is still involved with the team as an ambassador and is grateful that he can still throw with no pain. (Courtesy of John Moist, photographer.)

John "The Count" Montefusco, was a pitcher with the Giants from 1974 to 1980. When he arrived, he boldly proclaimed that he was going to beat the Dodgers. He proceeded to hit a home run at his first at-bat in order to help make it happen. He won the National League Rookie of the Year in 1975, and in 1976, he started in the All-Star Game. He threw a no-hitter on September 29, 1976, to beat the Atlanta Braves 9-0. The Giants would not see another no-hitter until Jonathan Sanchez in 2009. (Courtesy of Richard Macaluso.)

Jack Clark was nicknamed "Jack the Ripper" for his outstanding hitting ability. In 1978, he set a record for hitting in 26 consecutive games. He hit 340 home runs in his career, 163 of them as a Giant. He was traded to St. Louis before the start of the 1985 season for four players, including shortstop José Uribe. (Courtesy of Richard Macaluso.)

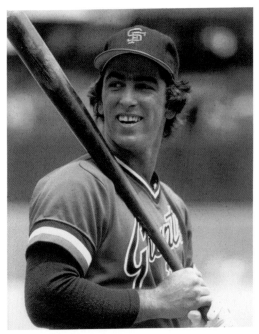

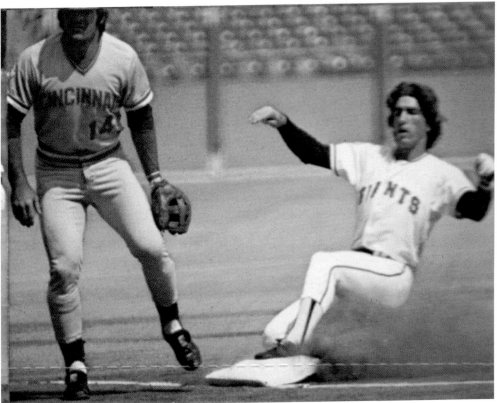

Jack Clark played with the Giants from 1975 to 1984, but he was not a fan of the freezing Candlestick Park. (Courtesy of Richard Macaluso.)

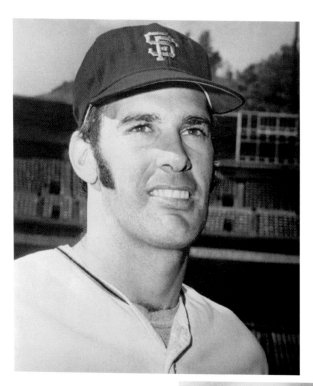

Jim Barr was a fiery pitcher who didn't shy away from confrontation. He played with Dave Kingman at the University of Southern California. He started pitching for the Giants in 1971 and helped the team win a Western Division title. He was a solid pitcher, setting a major-league record by retiring 41 consecutive batters—a record that would hold for 35 years. In 1978, he became a free agent and left the Giants. He struggled for several years but made a comeback with the Giants, mostly as a reliever, in 1982. (Courtesy of Pete Stoneham.)

Catcher Dave Rader debuted in the major leagues in September 1971 at age 22. He was awarded Rookie of the Year by the *Sporting News* in 1972. That same year he was runner up to John Matlack for National League Rookie of the Year. In 1976, he was traded to the St. Louis Cardinals along with John D'Acquisto and Mike Caldwell for Willie Crawford, John Curtis, and Vic Harris. (Courtesy of Pete Stoneham.)

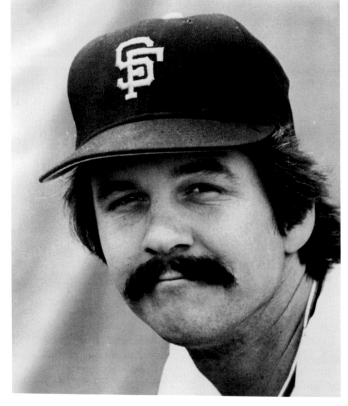

FROM THE TOUGH YEARS TO TRIUMPH

Pitcher Steve Stone was drafted as a fourth round pick in February 1969 and pitched in the minor leagues until April 8, 1971, when he made his major-league debut. In 1977, while pitching for Baltimore, Stone gave up Duane Kuiper's only career home run. Kuiper was playing for Cleveland at the time. (Courtesy of Pete Stoneham.)

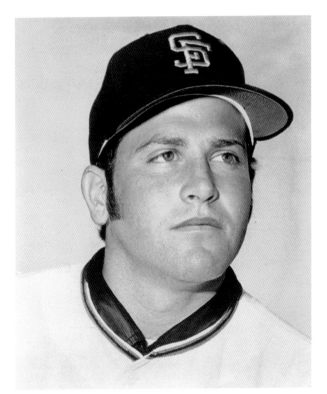

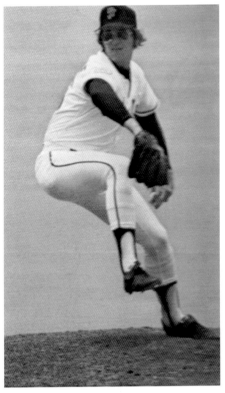

Gary Lavelle spent most of his career pitching for the Giants. He was with the team from 1974 to 1984 and pitched in a record 647 games—he earned 127 saves during that time. Lavelle was an All-Star in 1977. In 1983, Lavelle and Greg Minton each had 20 saves. The Giants traded Lavelle to the Toronto Blue Jays in January 1985. (Courtesy of Bob Lurie.)

Johnnie LeMaster ("Disaster LeMaster") was a shortstop and played 10 seasons with the Giants. On September 2, 1975, he debuted by setting a league record in his first at-bat by hitting an inside-the-park home run against the Dodgers. He is the 43rd player to hit a home run in his first major league at-bat. During the rest of his career, he hit only 21 home runs. In 1979, to show fans that he heard their calls of displeasure, he changed the last name on his uniform to "Boo" for one game. In 1983, he was seventh in the National League in stolen bases. (Courtesy of Bob Lurie.)

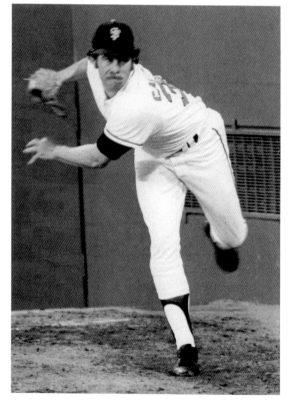

Mike Caldwell pitched for the Giants from 1974 to 1976. In 1974, he won 14 games and had a 2.95 ERA. He also pitched for the Padres, Reds, and Brewers. (Courtesy of Doug McWilliams, photographer.)

Marc Hill was a catcher for the Giants from 1975 to 1980. In 1983, he helped the Chicago White Sox win the American League Western Division. (Courtesy of Doug McWilliams, photographer.)

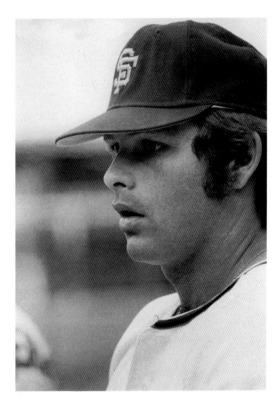

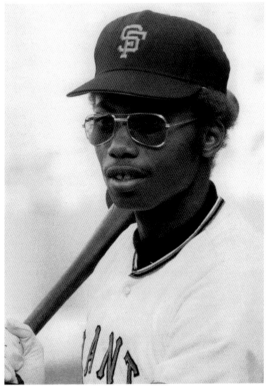

Derrel Thomas played every position except pitcher during his professional career. In 1969, he was a first-round amateur draft pick by the Houston Astros. He played with the Giants from 1975 to 1977. (Courtesy of Doug McWilliams, photographer.)

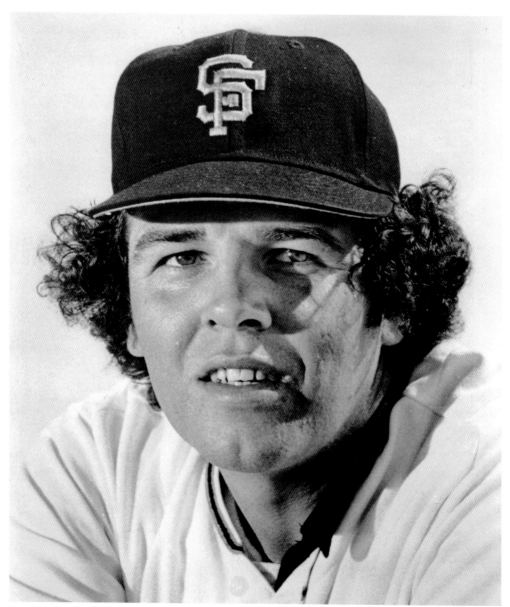

Pitcher Charlie Williams was playing for the New York Mets in 1972 when he was traded to the Giants for Willie Mays. His first year was spent between the Giants and their AAA team before taking a permanent slot on the roster as a reliever. He won 23 games in his career and had a career ERA of 3.97. His last game was at Candlestick Park in September 1978 against the rival Los Angeles Dodgers. (Courtesy of Pete Stoneham.)

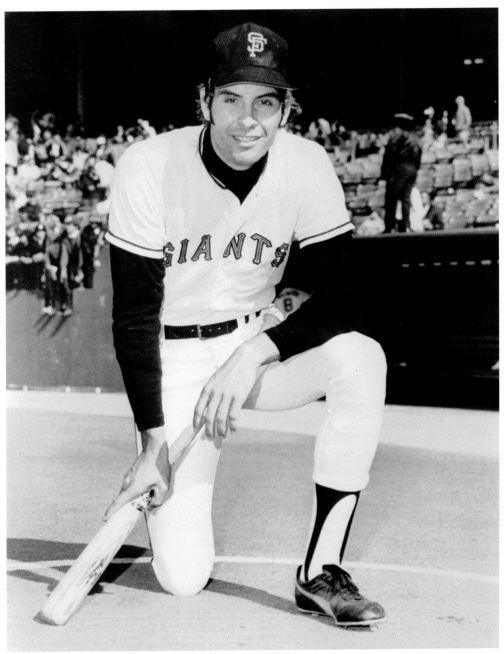

Dave Kingman played first base and sometimes third base for the Giants from 1971 to 1974. In his first major-league game, he was a pinch runner for Willie McCovey. His height, six feet and six inches with long arms, aided him in long, hard swings that tended to go to extremes with either home runs or strikeouts. He had 442 career home runs and finished his career with the A's in 1986. He had 35 homers in his final season and played alongside rookie José Canseco. His nicknames were "Kong" and "Sky King." After the 1974 season, the Giants sent him to the New York Mets. (Courtesy of Pete Stoneham.)

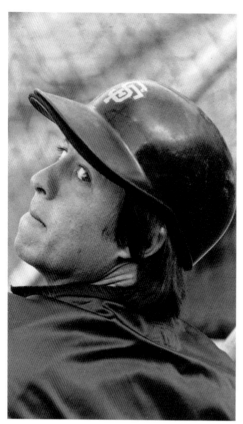

Outfielder Bobby Murcer was a reluctant Giant from 1975 to 1976, who played most of his career with the Yankees. He was traded to San Francisco for Bobby Bonds in the first even-money, superstar player, $100,000 exchange. On September 29, 1976, he caught the final out in John Montefusco's no-hitter. (Courtesy of Doug McWilliams, photographer.)

Second baseman Joe Morgan and Pete Rose, who in this photograph is with the Philadelphia Phillies, were teammates as a part of the "Big Red Machine" for the Cincinnati Reds. Morgan played two seasons for the Giants in 1981 to 1982. In 1982, he hit the famous home run that knocked the Dodgers out of the playoff race. He was also awarded the Willie Mac Award that year. Morgan was inducted into the Hall of Fame in 1990. He went on to become a successful television color analyst on ESPN Sunday Night Baseball alongside Jon Miller for years. (Courtesy of John Moist, photographer.)

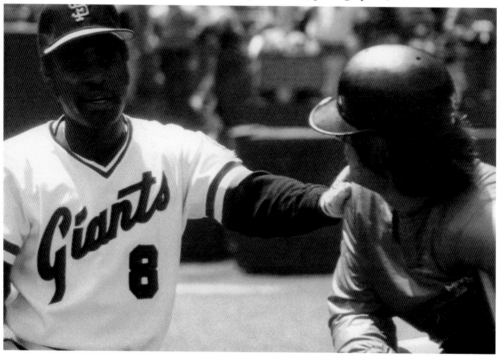

FROM THE TOUGH YEARS TO TRIUMPH

Left fielder Gary "Sarge" Matthews was the 1973 National League Rookie of the Year. He was part of the all-Gary outfield that also featured Gary Maddox and Gary Thomasson in the 1970s. He went on to have some very good years with Atlanta, Philadelphia, and Chicago after leaving the Giants. (Above, courtesy of Pete Stoneham; below, courtesy of Doug McWilliams, photographer).

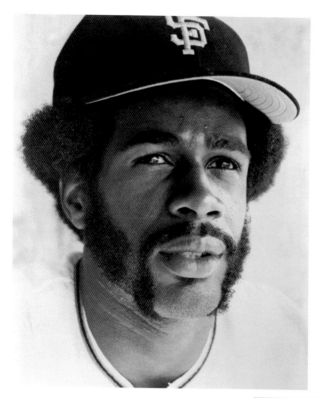

Center fielder Gary Maddox came up through the Giants farm league, making his major-league debut in 1972. He was traded to Philadelphia for Willie Montanez. Maddox was part of the Phillies for two World Series, in 1980 and 1983. He was also known as quite the base stealer. Maddox went on to win 7 Gold Gloves. (Above, courtesy of Pete Stoneham; below, courtesy of Doug McWilliams, photographer.)

FROM THE TOUGH YEARS TO TRIUMPH

Ed Goodson was a first-round draft pick who played first base, third base, and was a pinch hitter from 1970 to 1975. If you look closely, there is artificial turf instead of real grass at Candlestick Park in this photograph, a bad trend in the 1970s. (Courtesy of Doug McWilliams, photographer.)

Charles Theodore "Chili" Davis was born in Kingston, Jamaica, and is the first player from Jamaica to play in the major leagues. He played in the outfield with the Giants from 1981 to 1987. He was a switch-hitter who threw right-handed. In 1982, he led the National League in outfielder assists, and in 1984, he had the third highest batting average (.315) in the league. Chili was an All-Star in 1984 and 1986. (© 2011 Barry Colla Photography.)

Catcher Bob Brenly spent his career with the Giants, with the exception of the 1989 season, when he spent time with the Toronto Blue Jays. One of his memorable moments was in 1986 when his lead-off double in the ninth inning crushed Philadelphia Phillies pitcher Don Carman's chance for a perfect game. He coached for the team during the Roger Craig era and is now a very successful television color analyst with the Chicago Cubs. (© 2011 Barry Colla Photography.)

Atlee Hammaker came from Kansas City in a three-player trade for Vida Blue and pitched for the Giants from 1982 to 1990. Overall, 1983 was a good year for him, leading the league in earned run average (ERA) and walks plus hits per innings pitched (WHIP), and strikeout-to-walk ratio. He made the All-Star Team but was not so lucky in giving up the first-ever (and to-date only) All-Star grand slam to Fred Lynn of the California Angels. (© 2011 Barry Colla Photography.)

FROM THE TOUGH YEARS TO TRIUMPH

In his rookie year in 1982, Bill Laskey led the Giants with 13 wins, including a shut-out of Montreal in his first major-league game. He also started, and is credited with the win in the last game of the 1982 season against the Dodgers. That was the game where Morgan hit the game-winning home run to knock the Dodgers out of the playoffs. In 1983, he was named to the Topps and *Baseball Digest* All-Rookie Teams as a starting pitcher. He was also named pitcher of the month of May in the National League. He recognized the advantage of having former players, like Marichal, that he could talk to about pitching. (© 2011 Barry Colla Photography.)

Shortstop José Uribe was born in San Cristobal, Dominican Republic. In 1986, he came to the Giants from St. Louis along with David Green, Dave LaPoint, and Gary Rajsich in exchange for Jack Clark. In 1987, Uribe played a pivotal role in Game 5 of the National League Championship Series with a two-run single and later a stolen base that led to a score, helping the team win and take the lead in the series. He won the 1988 Willie Mac Award. A fan favorite, he was greeted with back and forth chants of "OHHHH" and "REE-BAY" when he came up to bat. By 1992, injuries had derailed his playing career. Sadly, in 2006 he was killed in a car crash at the age of 47. (© 2011 Barry Colla Photography.)

Candy Maldonado was born in Hamacao, Jamaica, and was nicknamed "The Candy Man" and "The Fourth Out." He was known for his hitting and had a memorable day in May 1987, when he became the 16th Giant ever to hit for the cycle. Later in 1987, during Game 6 of the National League Championship Series, he lost Tony Pena's fly ball in the lights, which led to a triple and ultimately won the game 1-0 to tie the series at three games apiece. He was the only Giant to hit a triple in the 1989 World Series. (© 2011 Barry Colla Photography.)

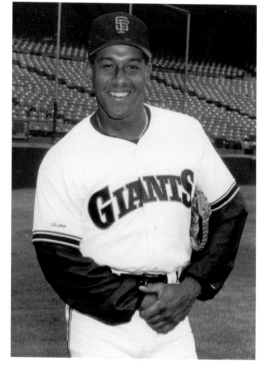

FROM THE TOUGH YEARS TO TRIUMPH

Chris Speier had two tours of duty with the Giants, first from 1971 to 1977 as a shortstop and again from 1987 to 1989 as a backup infielder. He made the National League All-Star team three years in a row in 1972, 1973, and 1974. He was traded to the Montreal Expos in exchange for Tim Foli. In 1987, he won the Willie Mac Award. (© 2011 Barry Colla Photography.)

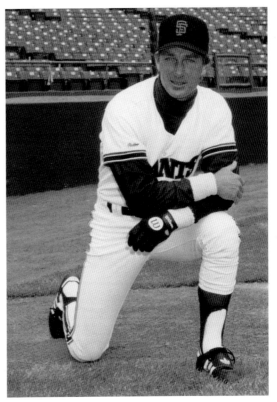

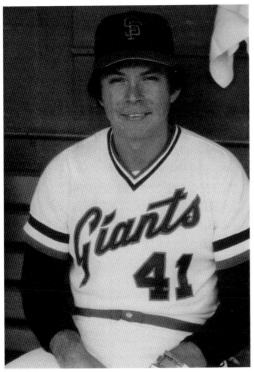

Darrell Evans played for the Giants from 1976 to 1983, after being traded by the Atlanta Braves along with Marty Perez for Jake Brown, Mike Eden, Willie Montanez, and Craig Robinson. He was primarily a third baseman, but in 1982, Tom O'Malley forced him to move to first base. In 1983, he hit 30 home runs, made the All-Star team, and won the Willie Mac Award. Evans was the first player to have 40 home run seasons in both leagues. (Courtesy of John Moist, photographer.)

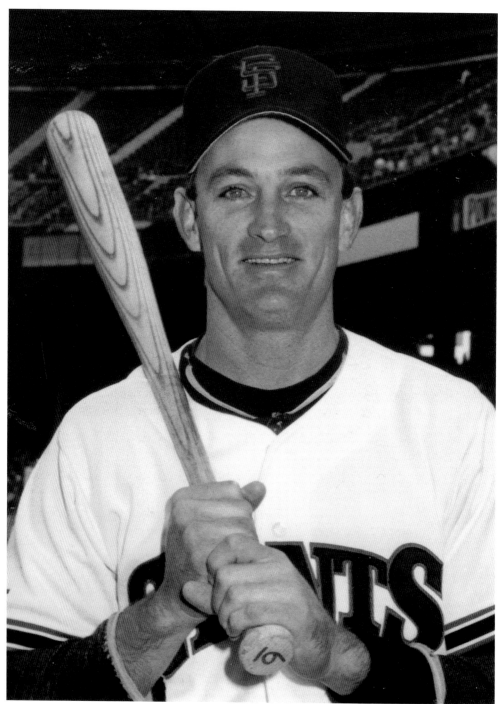

Robby Thompson was a true Giant, spending his entire major-league career from 1986 to 1996 as the team's second baseman. He was the complete package, with excellent batting, fielding, base stealing, and team leadership. Thompson and José Uribe were considered the best double-play combination in the league for several years. (© 2011 Barry Colla Photography.)

FROM THE TOUGH YEARS TO TRIUMPH

In 1986, Robby Thompson won the *Sporting News* Rookie of the Year Award and came in second for the National League Rookie of the Year Award. He won a Gold Glove and a Silver Slugger Award in 1993 and was an All-Star in 1988 and 1993. (Courtesy of Richard Macaluso.)

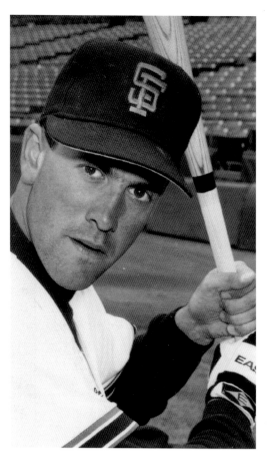

Will Clark was very respected for his dedication. He would take 500 practice swings a day. He spent only three months in the minors in 1985 before making the big-league roster to start the 1986 season. Clark played every game like it was the World Series, and he always wanted to win. His very first major-league game was against Nolan Ryan and the Houston Astros. The first pitch was a curveball, not very fast, but two pitches later he connected with a fastball and hit it over the fence. Another memorable moment was his base hit off Mitch Williams with the bases loaded to help win the 1989 National League Championship Series. He played in 1984 Olympics in Los Angeles. He was in a dogfight with San Diego's Tony Gwynn for the 1989 batting title, which came down to the final game of the season. Clark had one hit to finish with a .333 average. Gwynn had three hits to end up with a .336 batting average. Clark said he didn't think about it until after the Giants had clinched the division. (Courtesy of Will Clark.)

This photograph shows the mitt that belonged to Will Clark when he played in Baltimore toward the end of his career. He restitched the glove himself. Clark retired in 2000 after 15 years in the major leagues. (Courtesy of Morton Mah.)

FROM THE TOUGH YEARS TO TRIUMPH

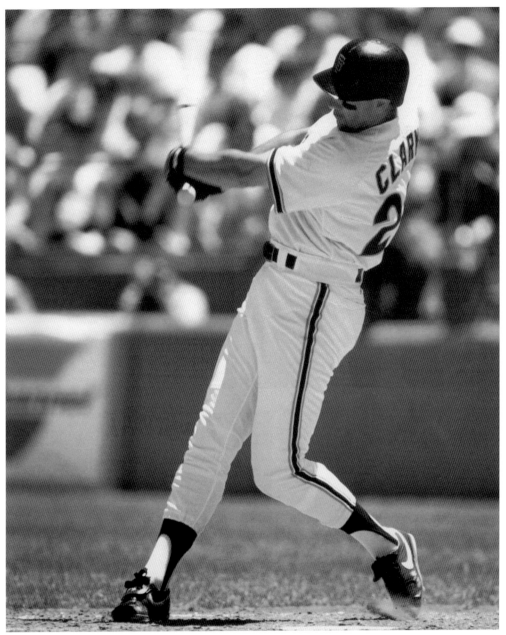

In 1989, during Game 1 of the National League Championship Series, Clark read the lips of pitcher Greg Maddux and Chicago Cubs manager Don Zimmer, and said, "Hey Kevin [Mitchell], guess what they're going to throw me—an inside fastball." Kevin said, "We've got a job to do." Will replied, "It's done." And it was—a grand slam. Had he kept his mouth shut, he may have been able to continue his lip-reading skills, but now players cover their mouths with the gloves. That same year, he won the National League Championship Series MVP and helped the team make it to the World Series. (Courtesy of Will Clark.)

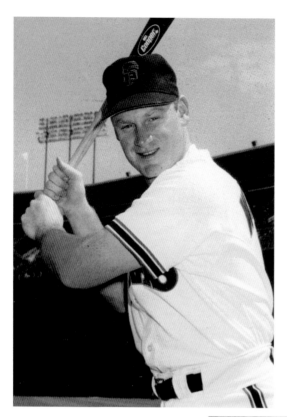

Third baseman Matt Williams played for the Giants from 1987 to 1996 after being selected with the third overall pick in the 1986 draft. He was a prime example of baseball brilliance in fielding and hitting. During his career, he hit over 30 home runs in six different seasons. In 1994, he was on track to break Roger Maris' all-time single season–home run record when the baseball season was cut short by a strike that canceled the World Series. He finished with 43 home runs and was second to the Astros' Jeff Bagwell for the National League MVP Award in 1994. (© 2011 Barry Colla Photography.)

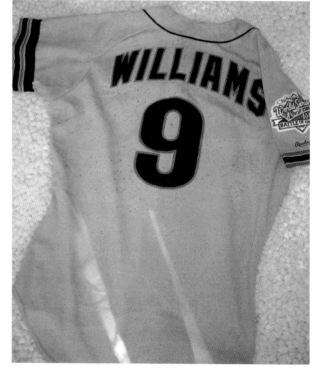

As a Giant, Matt "The Bat" Williams won three of his four Gold Glove awards, three of his four Silver Slugger Awards, and was an All-Star four times. He was traded to the Cleveland Indians in exchange for Jeff Kent, José Viscaino, and Julián Tavárez after the 1996 season. (Courtesy of Richard Macaluso.)

FROM THE TOUGH YEARS TO TRIUMPH

Kevin Mitchell came to San Francisco on July 4, 1987, to play third base. He was part of a trade that also brought Dave Dravecky and Craig Lefferts to the Giants. In 1989, he was moved to the outfield to make room for Matt Williams at third base. Mitchell followed Will Clark in the lineup; they were a potent one-two punch, probably the biggest since Willie Mays and Willie McCovey. Each time up, Clark would remind Mitchell that he was trying to get on base. The combination helped them reach the 1989 World Series only to fall to the Oakland A's in a four-game sweep. The two teammates were neck-and-neck for the National League MVP Award, with Mitchell receiving the honor—he had 47 home runs and 125 RBIs that year. He was the first Giants player to receive the award since Willie McCovey, who received the award in 1969. (Courtesy of Richard Macaluso.)

One of the most memorable moments for Kevin Mitchell was his barehanded catch of Ozzie Smith's fly ball in St. Louis that Mitchell actually overran. He still made the catch down the left-field line and then, luckily, ran through an open door under the stands to avoid smashing into the wall. (© 2011 Barry Colla Photography.)

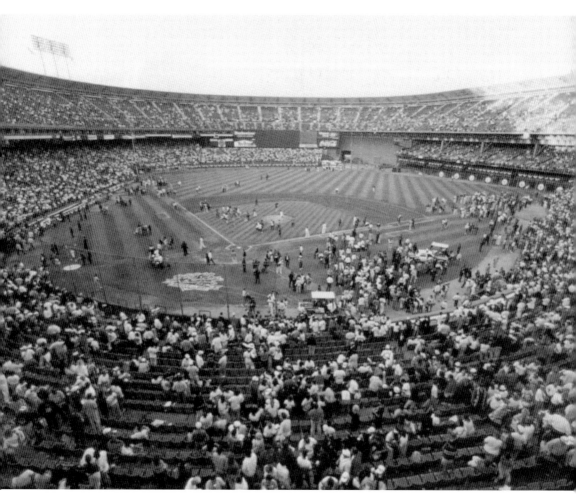

On October 17, 1989 at 5:04 p.m., Mother Nature shook the Bay Area with a whopping 7.1-magnitude earthquake. The earthquake was just minutes before the start of Game 3 of the World Series between the Giants and the Oakland Athletics. Given the magnitude of the shake, damage to the stadium, and massive power outages, the game was suspended until October 27. When play resumed, Oakland had a chance to come back with its two top starting pitchers and easily won the game 13-7. The A's also won Game 4 by a score of 9-6, sweeping the Giants. (Courtesy of Richard Macaluso.)

FROM THE TOUGH YEARS TO TRIUMPH

5:04 p.m.

Welcome back to the 1989 World Series

Before today's rescheduled Game 3 begins, Major League Baseball, the Giants, and the A's encourage everyone to join together in reflection of the events surrounding the earthquake which struck Northern California at 5:04 p.m. on Tuesday, October 17, 1989, minutes before Game 3 originally was to start.

The disaster took dozens of lives, injured thousands, left thousands homeless, and caused billions of dollars in damage. Its impact will be felt throughout Northern California for years to come.

At the same time, however, the earthquake mobilized an emergency army of dedicated public servants and private volunteers whose tireless relief efforts made heroes of ordinary citizens hour after hour.

We also salute and thank you, the 62,000 Candlestick Park fans, whose remarkable composure and restraint in the uncertain moments following the earthquake averted further chaos.

Tonight, we honor the resilience and indominatable spirit of our community to rise again. Let us all join together, not only in prayers for the loved ones lost, but in tribute to the survivors and selfless volunteers whose lives are changed forever.

We ask all our fans to take their seats before 5:04 p.m., when we will begin our pre-game schedule of activities.

On October 27, 1989, when Game 3 of the World Series resumed play 10 days after the Loma Prieta earthquake, fans received this flyer welcoming them back and asking them to take time to reflect on the events surrounding the earthquake. (Courtesy of Richard Macaluso.)

Pitcher Dave Dravecky came to the team in 1987 from the San Diego Padres as the star in a trade, along with Craig Lefferts and Kevin Mitchell. In the exchange, the Giants dealt Mark Grant, Mark Davis, and Chris Brown. In 1988, he had surgery on his pitching arm to remove cancerous cells. He made a comeback in August 1989, pitching eight innings for a win only to be devastated in his next appearance when his arm snapped during a pitch in Montreal. He fell to the ground in pain. He broke his arm a second time during the celebrations for the National League championship win. He lost his arm to cancer in 1991. He was an All-Star in 1983 and again in 1989. He won the Hutch Award and the Willie Mac Award. (© 2011 Barry Colla Photography.)

Don "The Caveman" Robinson pitched for the Giants from 1987 to 1991 after arriving in a trade from the Pittsburgh Pirates. He was scheduled to pitch Game 3 of the 1989 World Series, but the Loma Prieta earthquake postponed his start for 10 days. Robinson won 12 games and threw 197 innings for the Giants in 1989. (© 2011 Barry Colla Photography.)

Ernest Riles was traded by the Milwaukee Brewers to the Giants during the 1988 season for Jeffrey Leonard. He played shortstop and third base and hit the 10,000th Giant home run in franchise history. (© 2011 Barry Colla Photography.)

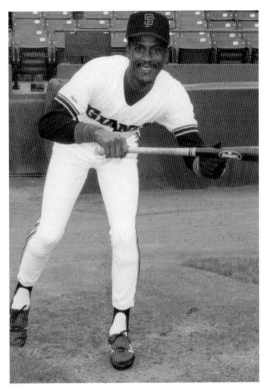

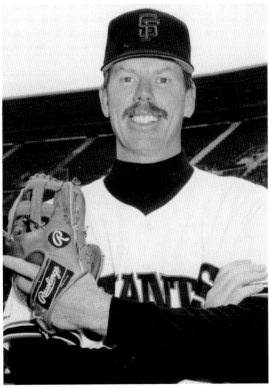

Mike "Buffy" LaCoss, pitched for the Giants from 1986 to 1991. In 1986, he hit his only two home runs in back-to-back games in which he started—one of his last at-bats against the San Diego Padres. In his next start, he homered in his first at-bat against the Cincinnati Reds' Tom Browning. (© 2011 Barry Colla Photography.)

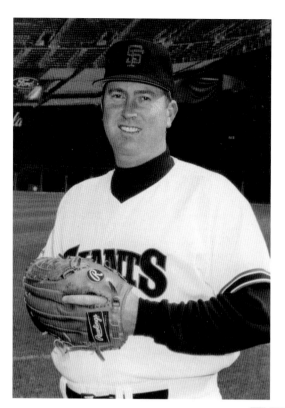

Pitcher Rick "Big Daddy" Reuschel came to the Giants in a trade with the Pittsburgh Pirates late in the 1987 season. The Giants gave up Jeff Robinson and Scott Medvin. Reuschel helped the team win its first National League Western Division title since 1971. He also won his second Gold Glove Award in 1987. In 1989, he won 17 games and helped the team make it to their first World Series since 1962. Reuschel was the losing pitcher in Game 2 of the series to the Oakland Athletics. He was an All-Star in 1989 and started the Summer Classic that year in the old Angels Stadium in Anaheim, California, yielding a home run to fellow All-Star Bo Jackson. (© 2011 Barry Colla Photography.)

Traded by the Colorado Rockies in mid-1998 for Darryl Hamilton, Ellis Burks stayed with the Giants through 2000. Burks provided an experienced power-bat, hitting fifth behind Barry Bonds and Jeff Kent and helping the team to achieve three winning seasons, including a National Leagues Western Division title. In 2000, he hit 24 home runs and drove in 96 runs, winning the Willie Mac Award, given in honor of Willie McCovey to a player who shows leadership and spirit. (© 2011 Barry Colla Photography.)

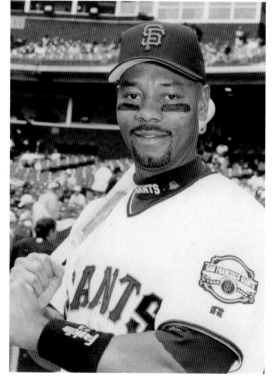

John McNamara was a coach with the Giants from 1971 to 1973. He managed six teams in the major leagues over a 20-year period. In 1986, he guided the Boston Red Sox to the World Series and won American League Manager of the Year. (Courtesy of Pete Stoneham.)

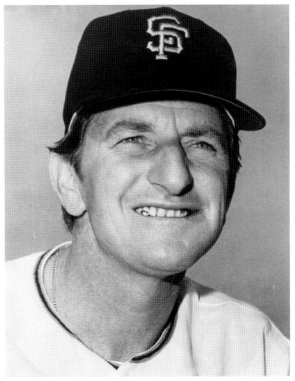

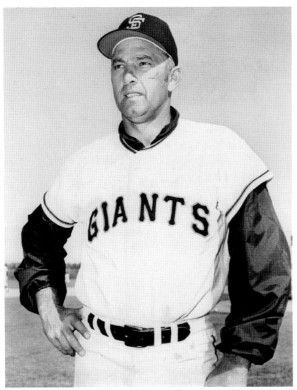

Jim Davenport managed the Giants in 1985. He had been a third-base coach but always wanted to be a manager. However, he maybe wished he had waited a little bit longer. They had a hard year, losing 100 games—he was fired before the end of the season and was replaced by Roger Craig. He really wanted to bring up Robby Thompson and Will Clark, but the team decided to wait. (Courtesy of Jim Davenport.)

Roger Craig took over the team at the tail end of the 1985 season as they were in the midst of losing 100 games. Two years later, he had them winning the division and coming within one game of the World Series. He knew how to put players in the right positions and was willing to take a chance on some new players. He was able to resuscitate the team and create a winning attitude. He also understood how to be positive, motivate players, and show the team how playing at Candlestick Park gave them a home-field advantage that they could use in their favor. Along with general manager Al Rosen, they were not afraid to make the necessary changes to create a winning team. "Humm, Baby" was his line. (Courtesy of John Moist, photographer.)

FROM THE TOUGH YEARS TO TRIUMPH

Third baseman Al Rosen played for Cleveland Indians from 1947 to 1956. He played in the 1954 World Series when the New York Giants swept the Indians. In 1953, Rosen had career highs with 43 home runs and 145 RBIs to go along with a .336 batting average. In 1985, Rosen was hired as the Giants' president and general manager, tasked with revising a 100-loss team. In a few short years, he helped turn the team into a winning organization and had them back in the World Series in 1989. Rosen was responsible for some important player acquisitions during this period, including Dave Dravecky, Craig Lefferts, Kevin Mitchell, Rick Reuschel, Don Robinson, and Steve Bedrosian. His reign did change the course of the Giants franchise and got them back on track for a successful future into the early 1990s. He resigned the position after the 1992 season. (Courtesy of Bob Lurie.)

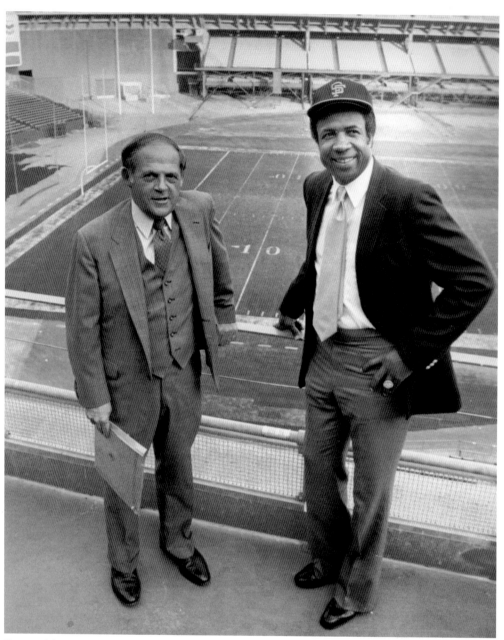

Pictured here are Bob Lurie and Frank Robinson at Candlestick Park with the football field configuration in place. The 49ers and the Giants shared the stadium, making it hard for players to get used to their clubhouse for the last third of the baseball season. As a player, Robinson won the MVP Award in both the American and National Leagues. As a manager, Robinson helped turn the team around and ushered in an era of success by 1982. By 1992, Lurie had made several attempts to get the city to build a new baseball-only stadium, but voters never approved the measures. Attendance dropped and Lurie started making plans to move the team to St. Petersburg, Florida. (Courtesy of Bob Lurie.)

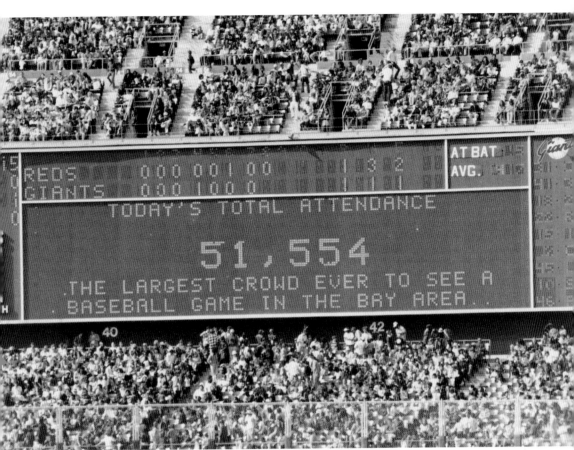

With threats of a sale, fans rallied to prove that they were faithful and could fill the stadium with a record attendance of 51,554. This photograph was taken during the final home game of the 1992 season against the Cincinnati Reds. The fans thought it was likely the last game before the Giants moved out of town. (Courtesy of Bob Lurie.)

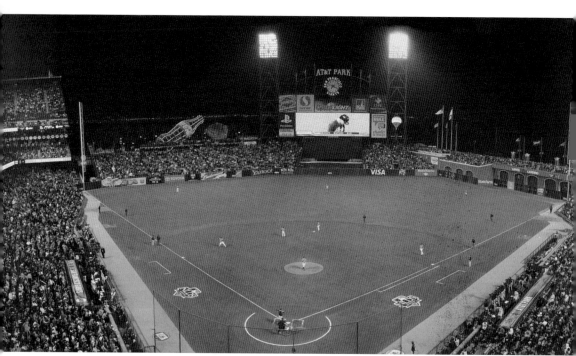

On January 12, 1993, Peter McGowan, with the help of Charles Johnson, Harmon and Sue Burns, and other investors, saved the team from being sold. McGowan took over as the Giants' president and managing general partner. He hired Bob Quinn away from Cincinnati as his general manager and signed free agent Barry Bonds as a star player to boost the roster and attendance numbers. Quinn brought in Brian Sabean as an assistant. Sabean was named general manager at the end of the 1996 season and remains the longest-tenured general manager in baseball as of 2011. In 2008, Bill Neukom replaced McGowan as the team's principal shareholder and head of the owner investor group. (Courtesy of Matt Soderstrom.)

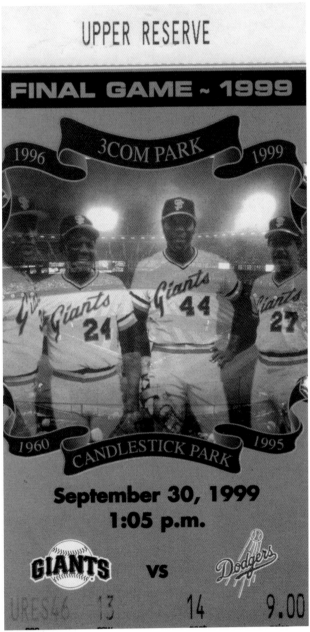

September 30, 1999, marked the bittersweet end to baseball at 3Com Park, which was formerly known as Candlestick Park, but if you asked any local, they would still call it "Candlestick" or "The Stick." Appropriately, the Giants hosted the rival Dodgers for the final regular season series at Candlestick. The stadium, which is more than showing its age, is still home to the NFL's 49ers, although the team (at the time of this printing) is trying to build a new facility in Santa Clara, California. After the final game, a helicopter landed on the field, took home plate out of the ground, and flew it to its new home at Third and King Streets. (Courtesy of Richard Macaluso.)

On April 11, 2000, after years of no luck with the voters and city politics, the Giants unveiled their privately funded, state-of-the-art stadium, Pac Bell Park. In its first year, the park ranked second in attendance after years of subpar attendance figures at Candlestick. Team president Peter McGowan named the clubhouse after Mike Murphy, in honor of Murph's long-term commitment to the team as clubhouse manager. The stadium is now known as AT&T Park. (Both images courtesy of Matt Soderstrom.)

FROM THE TOUGH YEARS TO TRIUMPH

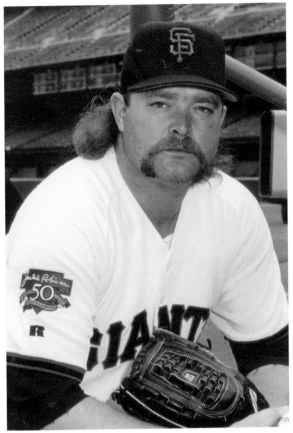

In the past, relief pitchers—especially closers—did not exist in the capacity that they do now. In the 1990s, Rod Beck was known as one of the greatest closers in the game. In 1993 alone, he saved 48 games. When asked about a memorable moment, Dusty Baker mentioned that a little girl had begged him not to put in Rod Beck. It was the 12th inning of a crucial game against the Dodgers. He inserted Beck, who retired Eddie Murray on a game-ending double play. Beck coined the term "Dustiny," as a tribute to team manager Dusty Baker. (© 2011 Barry Colla Photography.)

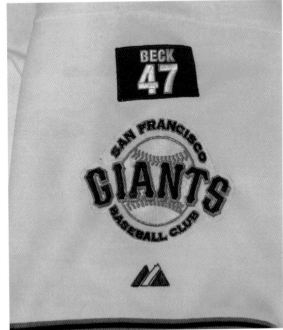

When Rod Beck passed away in 2007 at the age of 38, the team honored his memory by wearing this patch. (Courtesy of Richard Macalusco.)

Rich Aurilia is an example of what hard work and a little patience can do for a ballplayer. He spent several years in the minors before getting his shot. Dusty Baker had wanted to bring him up earlier, and after several years he was the starting shortstop in 1998. In 2001, he was hitting in front of Barry Bonds and enjoyed career highs, with 206 hits, 37 home runs, and 97 RBIs. Aurilia was an All-Star and won the Silver Slugger Award that year. He is credited with hitting the first-ever interleague grand slam against the Anaheim Angels. (© 2011 Barry Colla Photography.)

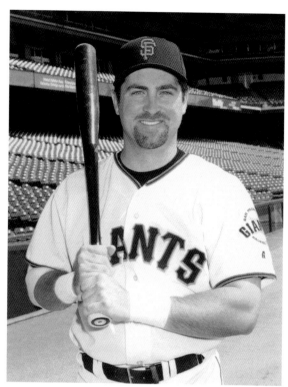

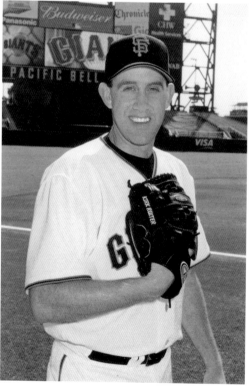

Pitcher Kirk Rueter ("Woody") played for the Giants for parts of 10 seasons and was known for being steady and dependable. He has the most wins (105) of any left-handed pitcher in the team's history. When the team moved to their new park in 2000, Rueter was the first pitcher on the mound. He was the winning pitcher in Game 4 of the 2002 World Series. Dusty Baker called him one of the funniest players on the team. (© 2011 Barry Colla Photography.)

Rob Nenn was the Giants' best closer from 1998 to 2002. He saved over 40 games for four consecutive seasons. He threw extremely hard with a mid-to-upper-90s fastball. His wicked slider earned him the nickname "The Terminator." On July 9, 2005, a plaque was placed near McCovey Cove at AT&T in honor of his 300th career save. (© 2011 Barry Colla Photography.)

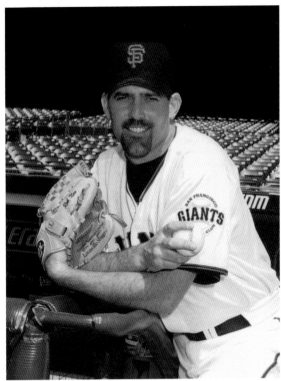

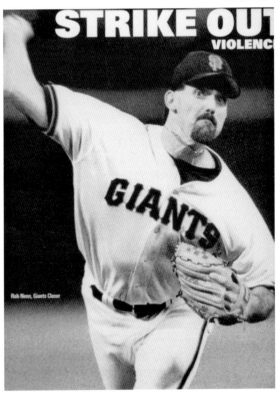

Pictured here is Giants closer Rob Nenn. He was featured on the "Strike Out Violence" poster for the Giants. Rockies game on September 13, 1998. The first 25,000 ticketholders received this commemorative poster when they entered 3Com Park. A portion of ticket sales went to help the Family Violence Protection Fund, funding grants for programs of survivors of violence and violence prevention. This has become an annual event. (Courtesy of Michael McGauley.)

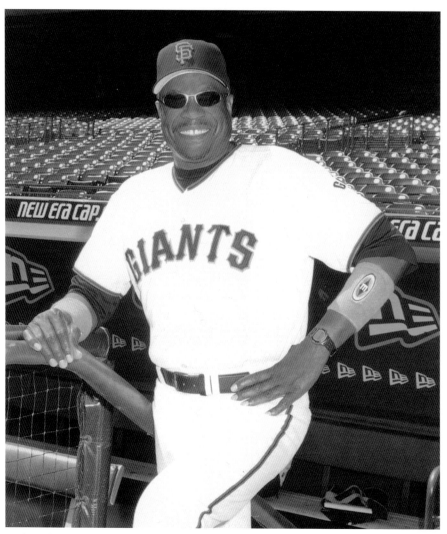

Dusty Baker played for the Giants briefly in 1984 and finished his career with the Oakland A's in 1986. That same year, Al Rosen sent Bob Kennedy over to ask Dusty if he would work for him. Dusty wanted to be the general manager's assistant, but Al Rosen told him he already had one. Rosen thought it would take four to five years to get the player out of him before he could be a manager, and it appears he was right. Robinson called on April 1, 1984, to talk about the job, but Dusty wasn't interested. Dusty's father also called and suggested that he take a vacation to think about the manager position and look for a sign to guide him. He headed to Lake Arrowhead, California, where Bob Lurie just happened to be vacationing too. Lurie saw Baker and immediately asked if he was going to work for him. Dusty's father said, "If that isn't a sign, then I don't know what is." He coached first base for the Giants in 1988 and was the hitting coach from 1989 to 1992. He replaced Roger Craig and managed the team from 1993 to 2002. Dusty won Manager of the Year his first year and again in 1997 and 2000. As a manager, his choice was talent over experience. Game 6 of the 2002 World Series was his personal nemesis. (© 2011 Barry Colla Photography.)

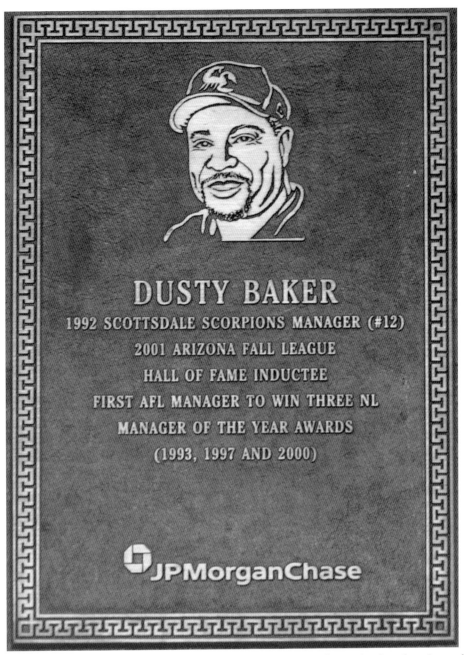

DUSTY BAKER

1992 SCOTTSDALE SCORPIONS MANAGER (#12)

2001 ARIZONA FALL LEAGUE

HALL OF FAME INDUCTEE

FIRST AFL MANAGER TO WIN THREE NL

MANAGER OF THE YEAR AWARDS

(1993, 1997 AND 2000)

JPMorganChase

This plaque highlighting Dusty Baker's achievements and awards can be found in Scottsdale at the Giants' spring-training ballpark. Dusty came up with the Atlanta Braves and was on deck when Hank Aaron hit his 715th home run, breaking Babe Ruth's record, in 1974. He hit a double after the famous moment, but he doesn't think anyone noticed. Hank Aaron told him, "It is okay to be nervous but don't be scared." Dusty said that the national anthem is the best part of the game because it gets him focused and ready to go out and win. (Courtesy of Doug Johnson, photographer.)

Barry Bonds started his major-league career with the Pittsburgh Pirates in 1986 and went on to play for the Giants from 1993 through 2007, after signing as a free agent. He worked very hard on his own and mostly away from his teammates. His stunning all-around talent created fan interest. He earned seven National League MVP Awards, including four in a row (2001–2004), 14 All-Star appearances, eight Gold Gloves, 12 Silver Slugger Awards, and three Hank Aaron Awards. He was also the all-time leader in walks and intentional walks. In 2001, he set a single-season record with 73 home runs. Bonds was the first Giant of the 21st century to win the MVP Award. Bonds is also one of a handful of players to have 500 career doubles and 500 stolen bases. (© 2011 Barry Colla Photography.)

FROM THE TOUGH YEARS TO TRIUMPH

Barry Bonds is the son of Bobby Bonds and grew up around baseball. Bobby and Barry both wore No. 25. Jim Davenport and Willie Mays were constant figures in his life due to their friendship with Bobby. On August 7, 2007, Barry Bonds hit home run number 756 off Washington Nationals pitcher Michael Bacsik, breaking Hank Aaron's record. He became the new home-run king of Major League Baseball and finished his career with 762 homers. (Courtesy of John Moist, photographer.)

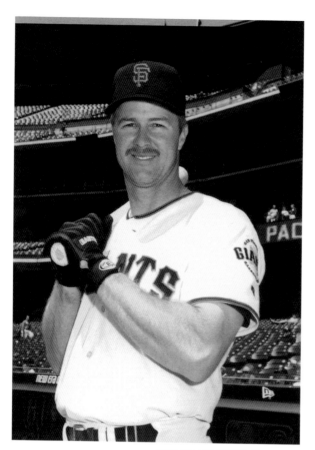

Second baseman Jeff Kent joined the Giants in 1997. He hit behind Barry Bonds to form a powerful hitting combination, one of the best the team had seen since the days of Clark and Mitchell. In 2001, he hit 49 doubles and had four consecutive seasons of 40 or more doubles. In 1998, 2000, and 2002, he blasted 30 or more home runs as a second baseman. In 2000, he won the National League MVP Award with a .334 batting average, 33 homers, and 125 RBIs. (© 2011 Barry Colla Photography.)

Jeff Kent is back working with the Giants as a spring-training coach. The hope is that his hitting skills and experience can help some of the current players. (Courtesy of Doug Johnson, photographer.)

Jack Thomas "J.T." Snow skillfully played first base for nine seasons with the Giants. In June 1999, he successfully pulled off the hidden ball trick and tagged out Carlos Perez of the Dodgers. Snow famously scooped up the tiny Darren Baker to get him out of harm's way as he was scoring a run during Game 5 of the 2002 World Series. That play changed the minimum age of batboys to 14 in the big leagues. (© 2011 Barry Colla Photography.)

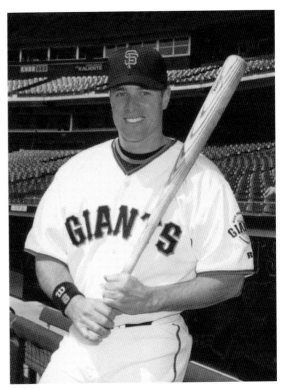

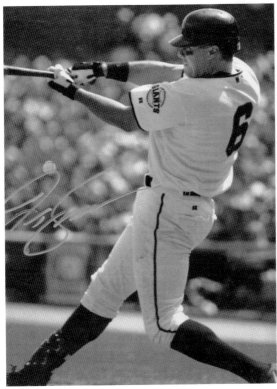

J.T. Snow is a six-time Gold Glove Award winner. He earned the honor four times as a Giant. He is also a two-time winner of the Willie Mac Award. Snow's dad, Jack Snow, was a wide receiver in the NFL with the Los Angeles Rams. (Courtesy of Kate Zawistowski.)

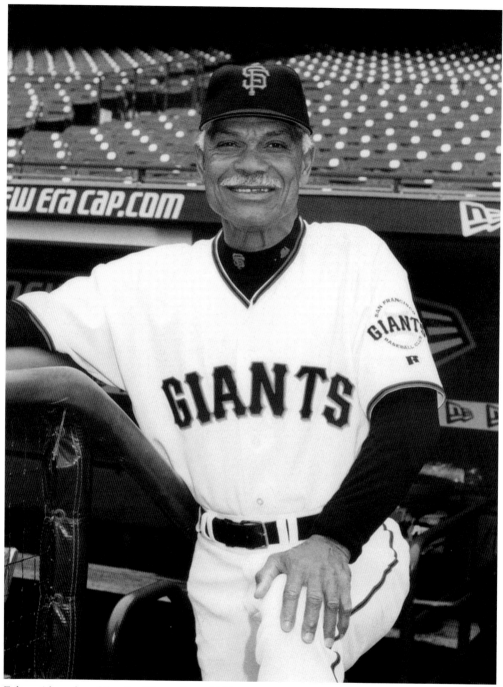

Felipe Alou played for the Giants from 1958 to 1963. He was an All-Star in 1962. In 1963, he and his brothers Matty and Jesús made up the first all-brother outfield. He went on to manage the Giants in 2003, replacing Dusty Baker, and took the team to the playoffs with a 100-win season. The eventual world-champion Florida Marlins knocked the Giants out of the postseason that year. (© 2011 Barry Colla Photography.)

FUN FOR FANS

Mike "Murph" Murphy is the equipment manager for the Giants and has been with the team since they arrived in town from New York. His mother is from Mexico, his father is from Ireland, and he was born in San Francisco. He attended public school in the city. His idol was Mickey Mantle, whom he met in 1962. In 1958 to 1959, he was the visiting team's batboy at Seal Stadium and got to meet the big names from the other teams. At the same time, he tried out for the East/West Shrine Game. Charlie Logan was the scout for the Red Sox, and Murph was the last guy to get cut. He is friends with all the players and says it hurts when a player is traded or retires. He has never missed a home game in the last 50-plus years. Before television, he had to carry a radio to know what was happening. Television in the clubhouse really changed things and allowed them to actually see what was going on in real time. Murph is the one who orders equipment and towels. They get new items every year. His special memories are the back-to-back no-hitters by Gaylord Perry and Ray Washburn in consecutive games, and when Willie Mays hit his 600th home run. In 2010, he was given the honor of carrying the World Series trophy into the clubhouse for the team. (© 2011 Barry Colla Photography.)

Hank Greenwald entered the world of Giants broadcasting thanks to Lindsay Nelson. He announced Giants games for eight years, and then he went to the Yankees for two years before returning to the Giants for eight more years. Greenwald was a fan from the New York days, and he brought that old-time perspective and insight to his play-by-play work. He was with the Giants during some of the tough years, but his ability to call the games and fill the gaps (especially during rain delays) with interesting stories and a dry sense of humor grabbed people's attention and turned listeners into fans. (Courtesy of Hank Greenwald.)

Souvenirs have always been part of the fans' agenda as a way of bringing the baseball experience home or to show their support during a game. The menu used to be much simpler than today's gourmet offerings. (Courtesy of Richard Macaluso.)

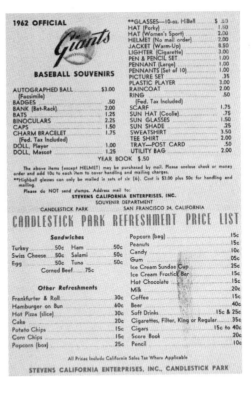

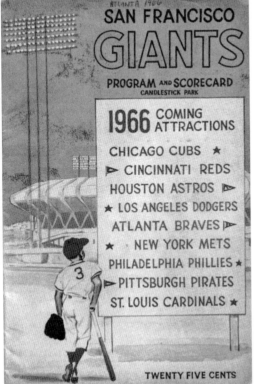

Programs and scorecards have always been an important part of the game-day experience. (Courtesy of Richard Macaluso.)

This 1980 Giants season schedule shows the wins and losses as tracked by owner Bob Lurie. They played 161 games with 75 wins and 86 losses, finishing in fifth place that year. Dave Bristol was the manager, Jack Clark led the team with 22 home runs, and Vida Blue led the team in wins with 14. (Courtesy of Bob Lurie.)

The Giants have had a long-standing arrangement with radio station KNBR 680-AM to broadcast the team's games live. The station has also served as a marketing-promotion partner to entice fans to attend games. Creative billboards like this one were scattered around the Bay Area. (Courtesy of Bob Lurie.)

Candlestick Park had a tendency to get windy, foggy, and very cold, especially during the night games in the summer. The Croix de Candlestick, an orange pin with snow on the "SF" logo, was created to reward fans for their loyalty when they stuck it out and stayed for extra innings. In 1984, a special All-Star version was created, featuring Stu Miller being blown off the mound during the 1961 All-Star Game. (Courtesy of the author.)

The Giants issued several patches for fans to wear. An extra special patch is the "I Got It" patch, also known as the Golden Hands Award. It was given to a fan when they caught a foul ball at Candlestick Park. The usher would present the patch to the recipient right there in the stands. There was adhesive on the back so it could be worn immediately. (Courtesy of Richard Macaluso.)

Still friends, Juan Marichal and Hobie Landrith return for an Old-Timers Game. (Courtesy of Hobie Landrith.)

In 2005, the Giants honored Juan Marichal by wearing Gigantes on their jerseys. They continued the tradition for several years to pay tribute to the rich history of all of their Latin American players. (Courtesy of Richard Macaluso.)

Bob Lurie and Hobie Landrith are pictured at the Old-Timers Game. The Giants are good about bringing players back for the fans and remembering the team's great history. (Courtesy of Bob Lurie.)

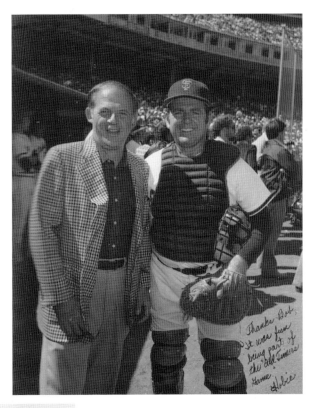

Fantasy Camp is an opportunity for fans to become players and be coached by former Giants players. It's a dream come true for someone who has always wanted to try their hand at the game and be coached by the best. (Courtesy of Bill Laskey.)

The Giants created several anniversary patches to celebrate the team's history in San Francisco for 25, 40, and 50 years. They also made a special patch when the team ended their reign at Candlestick Park (3Com Park), a bittersweet transition in 1999. (Courtesy of Richard Macaluso.)

The Giants have hosted three All-Star Games, two at Candlestick in 1961 and 1984, and one at AT&T Park in 2007. These special patches were created to celebrate the All-Star Games in San Francisco. (Courtesy of Richard Macaluso.)

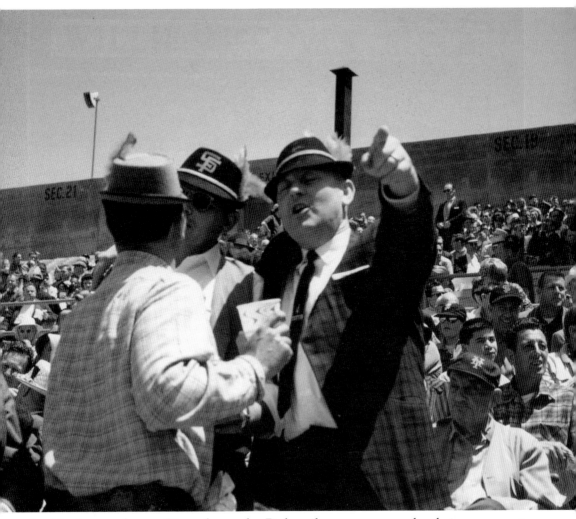

In this photograph, two Giants fans and a Dodgers fan argue over a play during a game at Candlestick Park. The rivalry between the two teams is still going strong. (Courtesy of Martin Jacobs.)

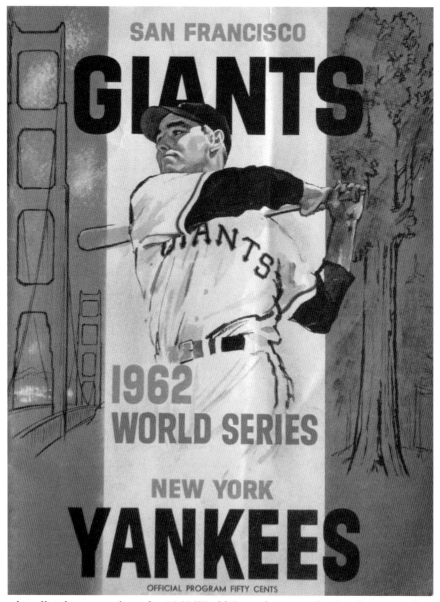

SAN FRANCISCO
GIANTS

1962
WORLD SERIES

NEW YORK
YANKEES

OFFICIAL PROGRAM FIFTY CENTS

This is the official program from the 1962 World Series between the San Francisco Giants and the New York Yankees. The Giants won 103 games that year and made their first World Series appearance since moving west. The Giants lost the series in seven games, dropping Game 7 at Candlestick. In the bottom of the ninth inning, with Matty Alou and Willie Mays on base, Willie McCovey ripped a super hard-line drive into Bobby Richardson's glove, ending the game and the series. The Giants fully expected to win against the Yankees. After all, they had a fantastic, well-rounded roster, with Willie Mays, Willie McCovey, Matty Alou, Orlando Cepeda, Jim Davenport, and Tom Haller. Their pitchers included Juan Marichal, Gaylord Perry, Billy Pierce, and Jack Sanford. It wasn't meant to be for the Giants. No one dreamed it would take until 2010 for San Francisco to finally win a World Series title. (Courtesy of Richard Macaluso.)

The San Francisco Giants have played in three World Series (1989, 2002, and 2010). Shown here are the special patches worn by the players to celebrate the various occasions. (Courtesy of Richard Macaluso.)

This photograph shows the flotilla of boats in McCovey Cove as fans try to catch baseballs hit out of the park before they splashed in the water. This was especially popular while Barry Bonds was chasing the home run record in 2001. The Giants have a "Splash Hits" counter along the right field wall that keeps track of every Giants home run to reach the cove. So far, there have been 55 "splash hits," with Barry Bonds hitting 35 of those homers. The other 20 belong to the following: Felipe Crespo, José Cruz Jr., Ryan Klesko, A.J. Pierzynski, Michael Tucker, J.T. Snow, Randy Winn, John Bowker, Fred Lewis, Nate Schierholtz, Andres Torres, Aubrey Huff, and Pablo Sandoval. (Courtesy of Richard Macaluso.)

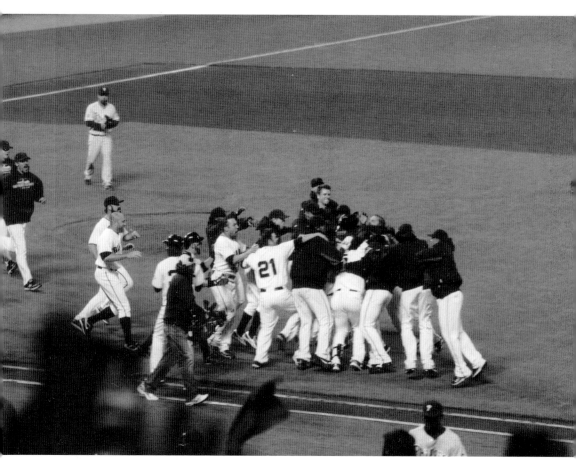

After the Barry Bonds era, the team had a chance to rethink its identity. They started focusing on drafting pitchers, and it seems to have worked, especially with Matt Cain and Tim Lincecum. In 2010, they didn't necessarily have the best team on paper, but everyone found their role, and they fought for each other and performed like a true team. This photograph shows the results as they celebrate their victory in the National League Championship Series over Philadelphia, propelling them into the World Series. (Courtesy of John Moist, photographer.)

FUN FOR FANS

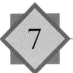
WORLD CHAMPIONS

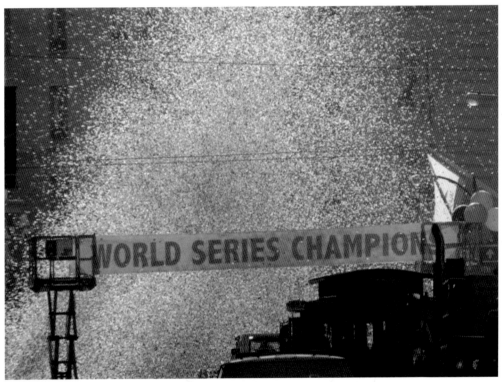

The San Francisco Giants became the World Series champions for the first time since moving to the West Coast. The franchise had not won a World Series since 1954. Considered a long shot, this motley crew made it happen with manager Bruce Bochy and players like Tim Lincecum, Buster Posey, Matt Cain, Cody Ross, Brian Wilson, Aubrey Huff, Edgar Renteria, Pablo Sandoval, Madison Bumgarner, Jonathan Sanchez, Sergio Romo, Juan Uribe, Jeremy Affeldt, Santiago Casilla, Javier Lopez, Guillermo Mota, Ramon Ramirez, Mike Fontenot, Travis Ishikawa, Freddy Sanchez, Pat Burrell, Aaron Rowand, Nate Schierholtz, Andres Torres, and Eli Whiteside. They did what no other San Francisco Giants team has done and became local heroes for eternity. (Courtesy of Doug Johnson, photographer.)

Shown here are tickets from the 2010 World Series. One was used for the first game of the series, but the other tickets were never used because Game 6 was never played. The Giants were able to wrap up the series in five games over the Texas Rangers. (Courtesy of Richard Macaluso.)

The 2011 world champions are pictured at the ring ceremony held at AT&T Park. Tiffany's designed the stunning championship rings. (Courtesy of Matt Soderstrom.)

WORLD CHAMPIONS

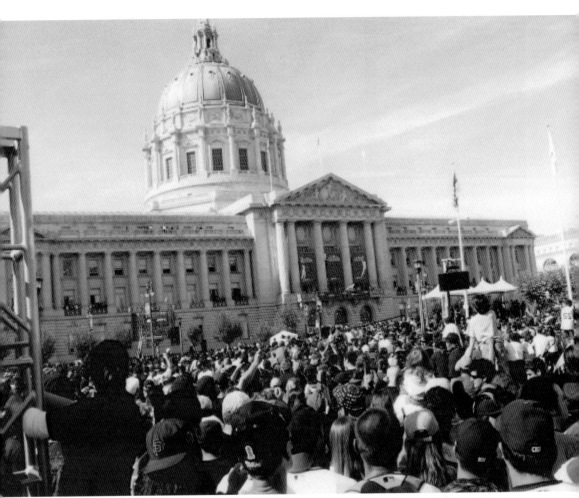

On November 3, 2010, just two days after the Giants finished off the Texas Rangers in five games of the World Series, the entire Giants organization participated in an epic celebration parade. The parade route was the same used by the original San Francisco Giants after they relocated from New York in 1958. After the parade, the players' images were splashed across City Hall during the official ceremony congratulating the team and presenting them with a key to the city. It is estimated that over one million people attended the parade and presentation in San Francisco to celebrate the Giants' long-awaited World Series victory. There was not a single arrest made. (Courtesy of Doug Johnson, photographer.)

On July 9, 2009, Jonathan Sanchez was moved out of the bullpen to replace injured veteran pitcher Randy Johnson. With his father in the stands, Sanchez pitched the first Giant no-hitter at AT&T Park against the San Diego Padres. Sanchez, from Puerto Rico, was drafted by the Giants in 2004 and made the big leagues in 2007. (Courtesy of Matt Soderstrom.)

Pablo Sandoval is known for swinging the bat and blessing himself after each successful hit. Barry Zito gave him the nickname "Kung Fu Panda," after Sandoval jumped over the glove of Los Angeles Dodgers catcher Danny Ardoin to score from second base on a single. While it is always fun for fans and players to have a home run land in McCovey Cove, Sandoval delivered his first McCovey Cove splash hit on Willie McCovey's 50th anniversary of joining the team, on July 30, 2009. Also in 2009, he became the only Giants switch hitter with as many as 189 hits in a season. His weight became an issue in 2010, but he arrived at spring training in 2011 lean and mean, after dropping 40 pounds. (Courtesy of John Moist, photographer.)

WORLD CHAMPIONS

From 2008 to 2010, Brian Wilson had the most saves in baseball: 127. In 2010, as the Giants prepared for their eventual World Series run, he grew a beard and dyed it black, starting a trend that spread to others in the bullpen and onto the fan base. Soon, "Fear the Beard" became the rallying cry. (Courtesy of John Moist, photographer.)

Outfielder Cody Ross, "Ross the Boss," played for four other teams before joining the Giants as a waiver claim at the end of the 2010 season. He is one of the few players who bats right, but throws left-handed. In the 2010 National League Division Series, Ross played a pivotal role for the Giants, hitting a home run to tie Game 4 against the Braves. He drove in the winning run in three of the four games as the Giants took the series. He continued his tear in the National League Championship Series against Philadelphia, highlighted by a two-homer game against ace pitcher Roy Halladay in Game 1. The Giants advanced to the World Series, and Ross was awarded the 2010 NLCS MVP Award. He finished the postseason with five home runs and 10 RBIs. (Courtesy of Matt Soderstrom.)

Catcher Buster Posey was called up from the minor leagues on May 29, 2010. In July, he was named National League Player of the Month and Rookie of the Month. By the end of the season, he was awarded National League Rookie of the Year with 18 homers and 67 RBIs to go with a .305 batting average. (Courtesy of Matt Soderstrom.)

Ace pitcher Tim Lincecum was drafted out of the University of Washington. He won back-to-back Cy Young Awards in 2008 and 2009, leading the National League in strikeouts both years. He is nicknamed "The Freak" and "The Franchise." In 2008, Lincecum received the Players Choice Award for outstanding pitching in the National League and won the Pitcher of the Year by the *Sports News*. (Courtesy of John Moist, photographer.)

Posey and Lincecum are shown here during spring training in Scottsdale in 2011. We will see what the future holds for the two cornerstones of the franchise. (Courtesy of Doug Johnson, photographer.)

Manager Bruce Bochy leads the team into the 2011 season. (Courtesy of Matt Soderstrom.)

www.arcadiapublishing.com

Discover books about the town where you grew up, the cities where your friends and families live, the town where your parents met, or even that retirement spot you've been dreaming about. Our Web site provides history lovers with exclusive deals, advanced notification about new titles, e-mail alerts of author events, and much more.

MADE IN THE USA

Arcadia Publishing, the leading local history publisher in the United States, is committed to making history accessible and meaningful through publishing books that celebrate and preserve the heritage of America's people and places. Consistent with our mission to preserve history on a local level, this book was printed in South Carolina on American-made paper and manufactured entirely in the United States.

This book carries the accredited Forest Stewardship Council (FSC) label and is printed on 100 percent FSC-certified paper. Products carrying the FSC label are independently certified to assure consumers that they come from forests that are managed to meet the social, economic, and ecological needs of present and future generations.

FSC

Mixed Sources
Product group from well-managed
forests and other controlled sources

Cert no. SW-COC-001530
www.fsc.org
© 1996 Forest Stewardship Council

Find Your Place in History.